Basic
Still Life
TECHNIQUES

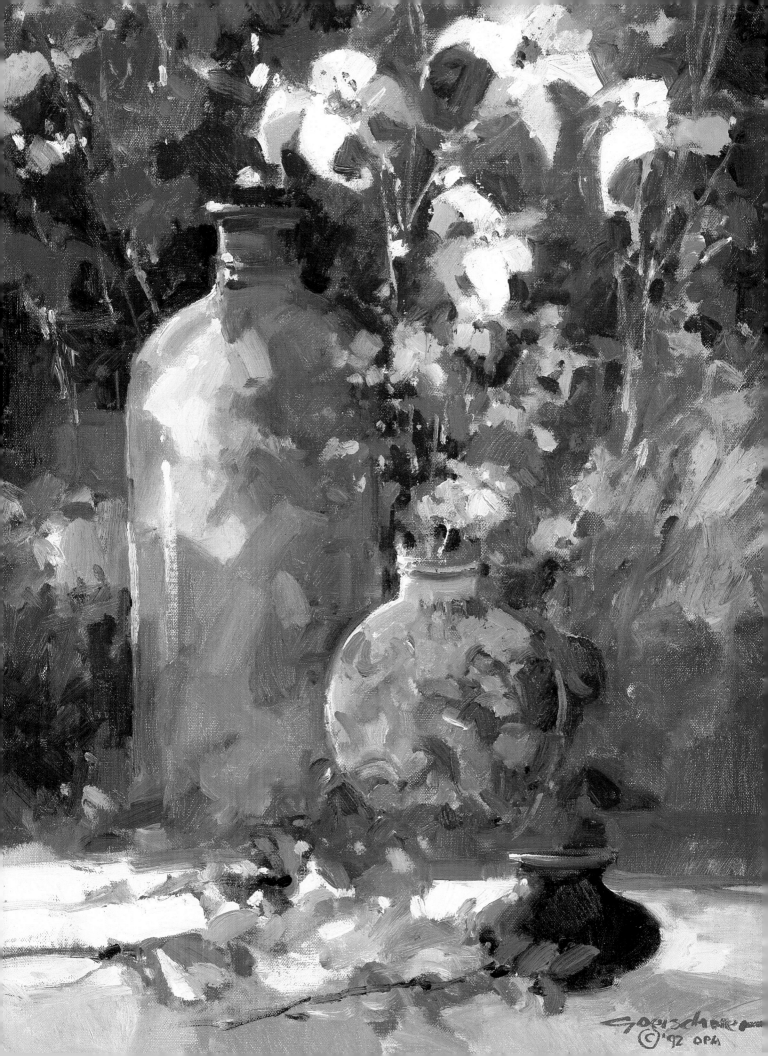

Basic
Still Life
TECHNIQUES

edited by
RACHEL WOLF

NORTH LIGHT BOOKS
Cincinnati, Ohio

Basic Still Life Techniques. Copyright © 1994 by North Light Books. Printed and bound in Hong Kong. All rights reserved. No part of this book may be reproduced in any form or by any electronic or mechanical means including information storage and retrieval systems without permission in writing from the publisher, except by a reviewer, who may quote brief passages in a review. Published by North Light Books, an imprint of F&W Publications, Inc., 1507 Dana Avenue, Cincinnati, Ohio 45207. 1-800-289-0963. First edition.

98 97 96 95 94 5 4 3 2 1

Library of Congress Cataloging-in-Publication Data

Basic still life techniques / edited by Rachel Wolf. — 1st ed.
 p. cm. — (North Light basic painting series)
 Includes index.
 ISBN 0-89134-588-4
 1. Still-life painting — Technique. I. Wolf, Rachel. II. Series.
ND1390.B27 1994
751.4 — dc20 93-48568
 CIP

Edited by Rachel Wolf
Interior design by Sandy Conopeotis
Cover design by Paul Neff

Artwork and text originally appeared in previously published North Light Books. (The initial page numbers given refer to pages in the original work; page numbers in parentheses refer to pages in this book.)

Albert Greg. *Drawing You Can Do It!* © 1992. Pages 94-95, 102-103, 108-109, 122-123 (pages 24-25, 38-39, 40-41, 42-43).

Dawson, Doug. *Capturing Light and Color With Pastel* © 1991. Pages 4-5 (pages 4-5).

Katchen, Carole. *Creative Painting With Pastels* © 1990. Pages 48-49 (pages 64-65) by Bill James; pages 2, 68-71 (pages viii, 102-105) by Jane Lund; pages 25, 114-117 (pages 72, 98-101) by Richard Pionk.

Katchen, Carole. *Dramatize Your Paintings With Tonal Value* © 1993. Pages 60, 63, 89, 91, 64-65 (pages 29, 44, 48, 49, 50-51; pages 110-111 (pages 94-95) by Jubb, Kendahl Jan; pages 54-55 (pages 92-93) by William Wright.

Kunz, Jan. *Painting Watercolor Florals That Glow* © 1993. Pages 44-45, 102-103, 104, 118-119 (pages 20-21, 66-67, 68, 88-89).

Kunz, Jan. *Watercolor Techniques: Painting the Still Life* © 1991. Pages 28-29, 32-33 (pages 90-91, 96-97).

Lehrman, Lewis Barrett. *Energize Your Paintings With Color* © 1993. Page 60 (page ii), by Ted Goerschner; pages 22-29 (pages 56-63), by Joni Falk.

Moran, Patricia. *Painting the Beauty of Flowers With Oils* © 1991. Pages 96-98, 84-85 (pages 69-71, 78-79).

Pike, Joyce. *Oil Painting: A Direct Approach* © 1988. Page 57 (page 13).

Pike, Joyce. *Painting Flowers With Joyce Pike* © 1992. Pages 51, 52-53, 20-21, 40-41, 24-25, 29-33, 22-23, 54-55, 56-57, 114-115 (pages 12, 14-15, 16-17, 18-19, 36-37, 73-77, 80-81, 82-83, 84-85, 86-87).

Smuskiewicz, Ted. *Oil Painting Step by Step* © 1992. Pages 16-17, 232-33, 42-43 (pages 22-23, 52-53, 54-55).

Sovek, Charles. *Oil Painting: Develop Your Natural Ability* © 1991. Pages 5, 61, 12-13, 14-15, 22-23, 30, 78-79 (pages 3, 5, 26-27, 28-29, 30-31, 24-27, 45, 46-47).

Stine, Al. *Watercolor Painting Smart* © 1990. Pages 6-7, 12-13, 16-18, 32-35 (pages 2, 6-11).

Woolwich, Madlyn-Ann C. *Pastel Intrepretations* © 1993. Pages 104-107 (pages 110-113) by Jill Bush; pages 108-109 (pages 114-115) by Foster Caddell; pages 102-103 (108-109) by Tim Gaydos; page 90 (page v) by William Persa; pages 100 (page 106) by Mary Sheehan; pages 92-93 (pages 116-117) by Anita Wolff.

Opposite title page: *Amber Jug, Ted Goerschner, 24" × 18", oil on canvas*

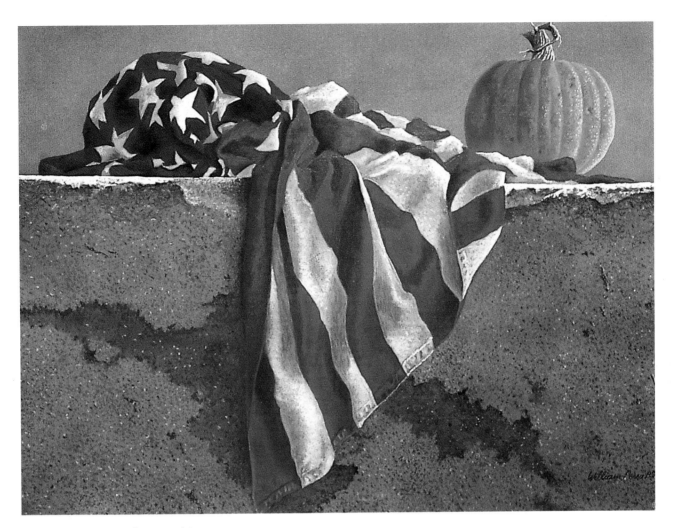

Stars and Stripes and a Pumpkin
William Persa
20" × 26"
pastel on paper

ACKNOWLEDGMENTS

The people who deserve special thanks, and without whom this book would not have been possible, are the artists and authors whose work appears in this book. They are:

Greg Albert
Jill Bush
Foster Caddell
Doug Dawson
Joni Falk
Tim Gaydos
Ted Goerschner
Bill James
Kendahl Jan Jubb
Carole Katchen
Jan Kunz
Lewis Barrett Lehrman
Jane Lund

Patricia Moran
William Persa
Joyce Pike
Richard Pionk
Scott Prior
Mary Sheehan
Ted Smuskiewicz
Charles Sovek
Al Stine
Anita Wolff
Madlyn-Ann C. Woolwich
William Wright

TABLE
of
CONTENTS

Introduction

1

Chapter One
BASIC MATERIALS
Everything You'll Need

•

Materials for Oil Painting

•

Materials for Watercolor Painting

•

Materials for Pastel Painting

2

Chapter Two
GETTING STARTED
Setting the Scene

•

Collecting Still-Life Objects

•

Arranging the Setup

•

Design and Composition

•

Background and Negative Space

•

Starting Out With Oil

•

Assemble a Still Life

12

Chapter Three
DEPICTING FORM
Painting Three Dimensions

•

Massing In Shape and Gesture

•

Defining the Form of an Object

•

Beyond Simple Shapes

•

Painting Groups of Objects

•

Painting a Whole Composition

•

Doing a Preliminary Drawing

26

Chapter Four
LIGHT AND SHADOW VALUES
A Strong Foundation

•

Make Your Drawing Clearer

•

Enhance the Illusion of Depth

•

Strengthen the Composition

•

Painting a Value Scale

•

Using Value to Create a Center of Interest

•

Shadows and Mood

38

Chapter Five
UNDER-STANDING COLOR PRINCIPLES
The Basics and More

•

The Primary Colors

•

Hue, or Family of Color

•

Tonal Value

•

Intensity or Saturation

•

Learning to See and Mix Good Color

•

The Palette and Color Wheel

52

Chapter Six
SPECIAL TECHNIQUES
For Some Difficult Subjects

•

Transparent Surfaces in Watercolor

•

Reflective Surfaces in Watercolor

•

Reflective and Transparent Objects in Oil

•

Surfaces for Pastel Painting

•

Using the Brush With Oil

•

Using the Knife With Oil

66

Chapter Seven
DEMONSTRATIONS IN
OIL

•

Beginning With a Neutral Tone

•

Fruit With Luster

•

Iris and Hat

•

Pretty Bouquet

•

Setting in the Yard

78

Chapter Eight
DEMONSTRATIONS IN
WATERCOLOR

•

Basket of Fruit

•

Casting Shadows

•

Designing With Black

•

Daisies: Painting Reflective Surfaces

88

Chapter Nine
DEMONSTRATIONS IN
PASTEL

•

Working From a B&W Photo

•

Interesting Studio Light

•

Rendering Fine Detail

•

Enhance Mood With Contrast

•

Creating Value Patterns: Two Views

•

Subdued Color for Intimacy

•

Layering With Fixative for a Glowing Surface

98

Index

118

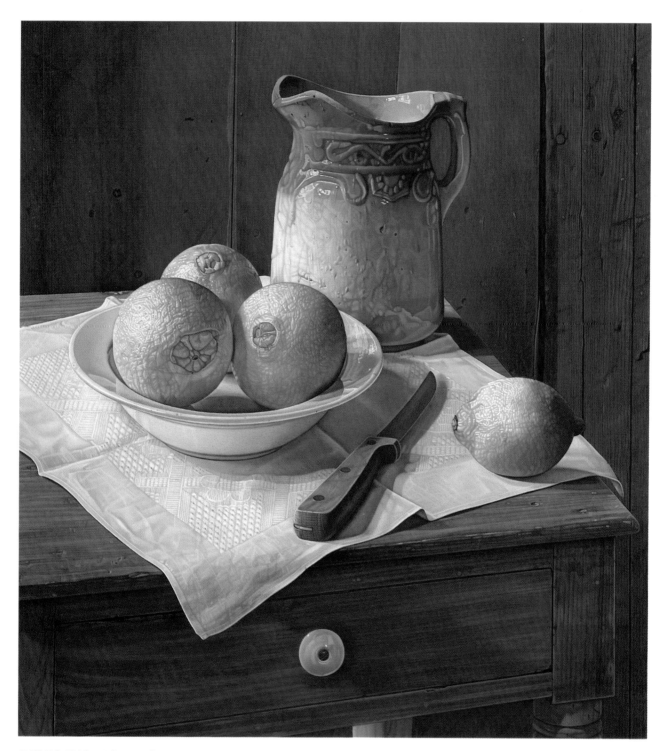

Still Life With a Blue Pitcher
Jane Lund
22″ × 20″
pastel

INTRODUCTION

Still life is one of the most traditional and enduring subjects. It is one of the most satisfying for both the artist and the viewer. In still-life painting, you can learn all the basics—form, value, lighting, composition, etc.—that will allow you to paint any subject well. You'll quickly see satisfying results with still-life painting.

This book offers instruction and encouragement to all painters, regardless of the medium the painter prefers. Oil, watercolor, pastel—they're all here.

We have assembled this book from some of the best teachings on still-life painting available—everything the beginner needs to get off to a smooth start. In the first chapters, you will find useful information on materials, color, depicting form, and special techniques for still-life subjects. The latter part of the book contains twenty-two demonstrations in oil, watercolor and pastel. The only additional ingredients you will need are practice and the knowledge that your interest and effort will overcome any lack of that elusive quality we call "talent."

Chapter One
BASIC MATERIALS
Everything You'll Need

Most painters are fascinated by all the equipment we use for painting. For most of us, this fascination began with our introduction to painting, when we were mystified and confused by all the materials needed. We were impressed with the array of brushes, paints and other paraphernalia that more experienced painters had accumulated. Most of us have since become gadgeteers and collectors, with a lifelong habit of picking up anything that might be useful.

Despite all the gizmos that most artists keep in their paint boxes or on their studio tables, we rarely use more than one or two of them on any one painting. Instead, we usually stick to the basics. Although it's fun to collect odds and ends for special tricks and effects, there is no magic in them. They won't do your painting for you.

Good painting begins with knowing what the basic tools and equipment will do. Eventually, you'll find it easy to choose a special tool for a particular texture or effect. In this section, we'll take a look at the essential tools needed for oil painting, watercolor and pastel.

In addition to getting the right materials and learning to use them, it's important to set aside a permanent place in your home to work, preferably one where you can retreat to paint undisturbed. Many artists have started their careers on the kitchen table, but having a space dedicated to your art can be a real asset. You'll find that you can focus your energies best in familiar surroundings with all your equipment close by. You'll associate your studio with creative activity, and it will be easier to get into the mood to paint there. It also helps to know where everything is so you can reach for a tool or brush without thinking about it.

Having the right light to paint by is also important. The ideal lighting is overhead, color-balanced fluorescent lighting. You don't want to be painting in your own shadow. Ordinary fluorescent bulbs are too cool and incandescent lights too warm for you to make good color choices. It can be a real shock to see a painting done in cool fluorescent light under warm incandescent light.

A good, round watercolor brush allows you to paint broad strokes with the side of the brush, as well as some finer detail with the point.

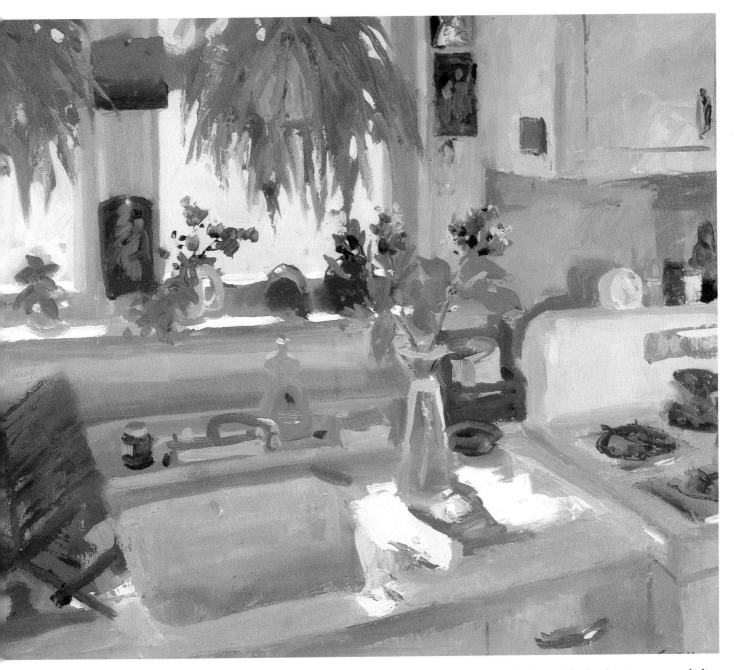

Kitchen Interior With Flowers
Charles Sovek
24" × 30"
oil on canvas
collection of Lori Cutler-Goodrich,
Rowayton, Connecticut

Many artists have started their careers on the kitchen table, but having a space dedicated specifically to your art can be a real asset.

Materials for Oil Painting

The following list includes all the materials needed for basic painting in oil. As your knowledge increases, so will your stock of materials and your sensitivity to different colors and brushes.

First, let's look at a list of suggested colors. They all don't have to be purchased right away. You can have a perfectly serviceable palette from just the colors with asterisks. Purchase the rest gradually, as desired.

Oil Colors

- cobalt violet
- alizarin crimson *
- cadmium red light *
- cadmium yellow medium *
- cadmium yellow pale
- Naples yellow
- burnt sienna *
- permanent green light
- Thalo or viridian green
- cerulean blue *
- black
- Thalo red rose
- brown madder
- cadmium orange
- cadmium yellow light *
- yellow ochre
- raw sienna
- burnt umber
- sap green *
- Thalo blue *
- cobalt blue
- Payne's gray
- white (large tube) *

Painting Knife

Be sure to get a painting knife with an inverted handle. It's much easier to manipulate than a flat palette knife.

Brushes

You need at least a dozen flat, bright or filbert bristles in sizes 1 through 12 (two of each of the even sizes nos. 2, 4, 6, 8, 10 and 12 are good ones to start with). A no. 5, 6 or 7 square sable softens edges and does detail work. Buy a small no. 2 or 3 square or round rigger for small accents and highlights unobtainable with any of the other brushes.

Brush Washer

A brush washer is a mandatory item for keeping your brushes clean between strokes. Silicoil makes a jar with a coiled wire at the bottom especially made for cleaning oil painting brushes. You may choose to buy the jar and not the can of cleaning fluid that's sold with it. Turpentine or paint thinner will do the job just as well and at a fraction of the cost.

You could also make your own brush washer by using an empty peanut butter or jelly jar with a coiled-up wire coat hanger at the bottom. Whether you buy or make a brush washer, your oil painting equipment isn't complete without one.

After a day's painting, clean your brushes one last time by first swishing them out in the cleaning jar and then thoroughly wiping them clean with your fingers using a mild soap and warm water. Make sure that no excess paint remains in the brush.

Brush Dauber

For a brush dauber, use a tuna or cat-food can stuffed with a couple of paper towels to daub off a drippy brush before mixing a fresh batch of paint.

Painting Surfaces

Stretched or unstretched primed cotton or linen canvas, canvas board or ⅛-inch Masonite (covered with two coats of gesso, one horizontal and one vertical) makes a suitable surface for oil paint. Sizes can range from panels as small as 9″ × 12″ all the way up to 20″ × 24″ or even larger. The best all-around sizes for the exercises in this book are from 11″ × 14″ to 16″ × 20″.

Palette

Plate glass with a piece of white paper or cardboard beneath it is ideal to use for a palette in the studio but impractical for travel and location painting because of its weight and fragility. White Plexiglas, on the other hand, is suitable for both purposes. Ideally, you should have both glass and Plexiglas, with Plexiglas cut to fit your painting box for field work and the larger plate-glass palette on your taboret for studio work. White or gray paper tear-off palettes are fine in a pinch but tend to deteriorate after repeated brushing.

If you do choose a paper palette, use two of them, a larger one for holding the colors squeezed from the paint tubes and a second, smaller one, placed on top of the first and reserved for the actual mixing of paint. When the smaller mixing palette is covered, simply tear off the filled page and you instantly have a fresh surface to work on without the inconvenience of disturbing the colors on the larger palette. Tan or brown natural wood palettes may be distracting to work on because the warm color and deep tone hamper judgment in mixing colors and values

objectively (especially when working on a white canvas).

Razor Blade Scraper

The hardware store variety scraper made for scraping old paint from a building or window is particularly useful for quickly scraping wet or dry paint from your palette and providing a clean space for new mixtures.

Medium

Use undiluted turpentine for laying in a painting with thin washes or toning a canvas. Some useful mediums are Res-N-Gel (Weber), Win-Gel (Winsor & Newton) and Zec (Grumbacher); while not as flexible as a mixture of stand oil (or linseed oil) and turpentine, they do give the paint a juicy quality that some painters find attractive. You'll also need some portable medium cups that can be stored in your painting box along with your paints and brushes.

Turpentine, Paint Thinner

Turpentine is used for washing out brushes. Wood-distilled gum turpentine is less of a health hazard than petroleum-based paint thinner or mineral spirits.

Paper Towels or Rags

Rags are okay but tend to get saturated quickly, so you may want to use a high-quality paper towel.

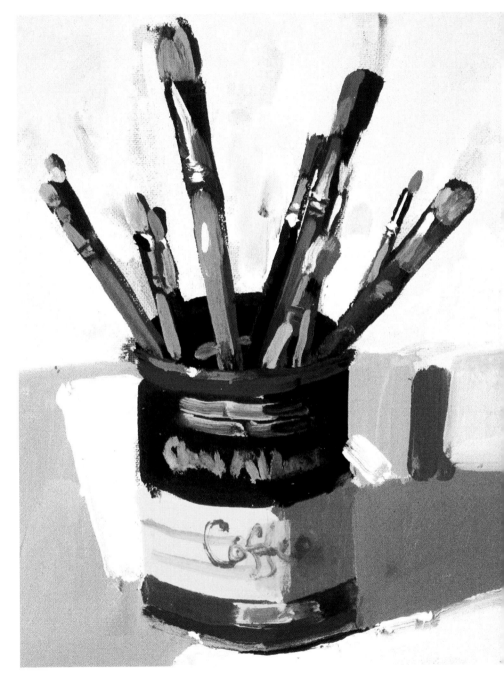

Brush Can
Charles Sovek
12" × 12"
oil on canvas
collection of Martha Rodgers,
Atlanta, Georgia

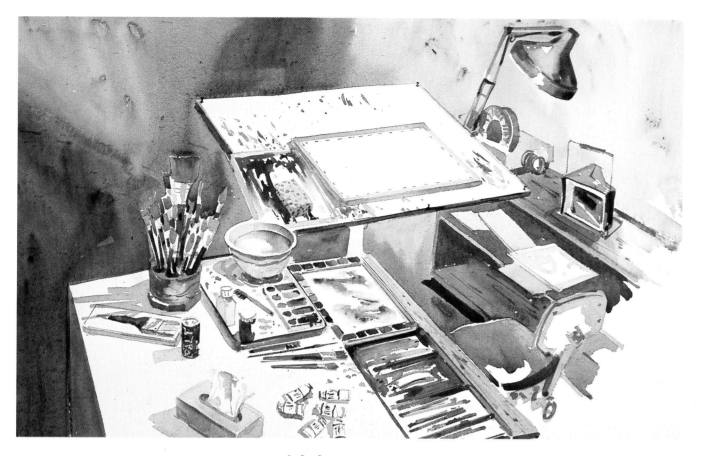

This is a watercolor of artist Al Stine's studio setup.

Materials for Watercolor Painting

Let's start with a look at the watercolor tools we just can't do without: brushes, colors, paper, a palette, boards on which to stretch the paper, water containers, sponges, tissue, a pocket knife, HB pencils, erasers, a spray bottle and a sketchbook. We'll also discuss some of the nonessential but handy items needed for special purposes.

Brushes

There are many excellent brushes on the market, and a few that are not so good. Buy smart when purchasing brushes. That almost always means buying the best brushes you can afford.

Red sable-hair brushes are the most expensive, but they are also undoubtedly the best. With proper care, they will last for a very, very long time and will prove to be a wise investment. If

you can't afford red sable, ox-hair brushes are a good second choice. There are also some new synthetic brushes that are much less expensive but have gotten good reviews from watercolor painters. They should be springy and hold a good point. Synthetic fiber brushes with some natural fibers, such as the Winsor & Newton series 101 Sceptre, are very good choices, especially the rounds.

The following selection of brushes is recommended for the beginner. There are enough brushes to get the job done but not so many that choosing the right one becomes troublesome when painting.

Use a 2-inch Robert Simmons Skyflow for wetting the paper, for painting backgrounds and for painting skies. This brush does have synthetic fibers but still holds a good charge of water. For a versatile selection, use

three red-sable flats—a 1½-inch, a 1-inch and a ¾-inch—and four red-sable rounds—nos. 12, 8, 6 and 4. The larger the number, the larger the brush. Use the largest brush you can when painting; small brushes invite fussiness. Keep an oil painter's ½-inch bristle brush for applying heavy pigment into wet areas and a small, ⅛-inch oil bristle brush for scrubbing and lifting out small areas of a painting for rocks and stones. Use a no. 4 rigger—a long, thin brush—to paint fine lines such as the rigging of ships, lacy tree branches and grasses.

Brushes are a major investment, so it pays to take good care of them. First, never use your sable or ox-hair brushes for acrylics, which tend to dry near the ferrule (the metal sleeve that holds the hairs on the wooden handle) and eventually ruin the springiness of the hairs. If you do use acrylics, use synthetic brushes.

Second, you should clean your watercolor brushes thoroughly after every painting session. Make it a habit to rinse them in clear water after each use. Many artists also use a mild soap to remove any residue that may linger in the bristles. Always make sure you rinse out all the soap.

Third, store the brushes in a way that protects the fibers, such as vertically in a brush holder, as shown in the illustration on page 5. Transport them taped to a piece of stiff cardboard. If you do store your brushes for a long time, put a few moth crystals in their container. Moths love sable hair. Of course, the best way to combat this problem is to use your watercolor brushes every day!

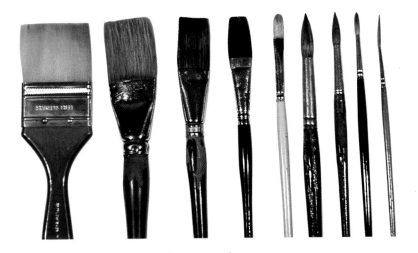

A selection of brushes appropriate for watercolors.

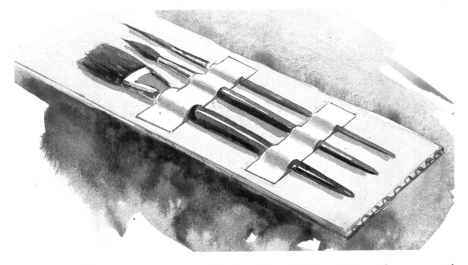

This is a good way to transport your brushes. For added protection, place a second piece of cardboard on top and tape the pieces together.

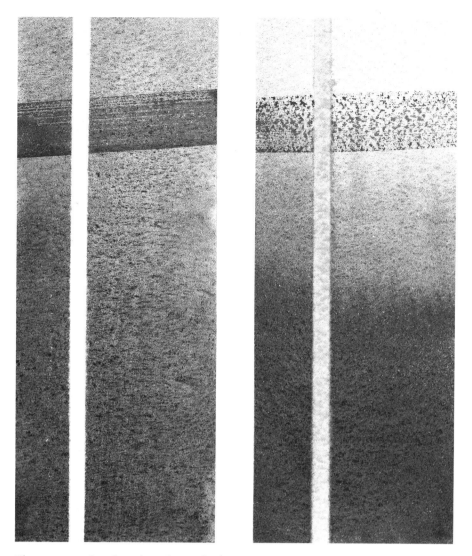

These are gradated washes of French ultramarine blue on 140-pound Arches cold-press paper (right) and 112-pound Crescent Rough Watercolor board (left). A strip of dry brush shows the difference in texture. Color was also lifted with a sponge after masking out an area with tape. As you can see, the color lifts off the board more easily than the paper, giving you much cleaner whites.

Paper and Board

Watercolor paper comes in various weights and textures. When we speak of the *weight* of the paper, we mean how much 500 sheets of a particular paper weighs. For example, if 500 sheets of a paper weigh 140 pounds, it's called 140-pound paper.

The less a paper weighs, the more it wrinkles and buckles when wet. Paper lighter than 140-pound will need to be stretched. The heavier papers can be held down on the drawing board with large clips, and the very heaviest can be used unmounted.

The standard size watercolor sheet is 22″ × 30″. You can purchase full sheets from your local art supply store or by mail order. A half-sheet (22″ × 15″) is the size most commonly used by watercolorists. Paper can also be purchased in blocks. Watercolor blocks are pads of paper glued together on all four edges; you work on the top sheet, then slide a knife around the edges to separate it from the block when dry. Blocks come in sizes from 7″ × 18″ to 18″ × 24″ and in a variety of weights and textures.

Watercolor papers come in several different textures. Very smooth paper is called hot-press because it's made by passing the paper between large, hot rollers. Cold-press paper has a more textured surface because it has not been subjected to heat in its manufacture. Rough paper has a distinctly textured surface.

Paper texture and technique are closely related. Some techniques will work on rough or cold-press paper but not on hot-press, and vice versa. For instance, dry-brush techniques are not very effective on the smooth surface of hot-press paper because the dry brush is supposed to deposit color on the ridges of the paper's surface. On the other hand, the smooth surface of the hot-press paper allows for easier lifts and wipe outs.

Basic Still Life Techniques

Palettes

You can use anything from a dinner plate to a butcher tray for your palette, but there are a number of excellent plastic palettes made just for watercolor. A John Pike palette, a plastic palette with a tight-fitting lid and twenty wells for colors, works well. The wells surround a large central mixing area and are separated from it by a small dam that keeps the mixtures from creeping into the colors. The top can also be used for mixing colors. This palette is airtight, so at the end of the painting session, you can place a small damp sponge in the center of the tray and replace the lid. The colors will stay moist and ready for use for several days.

Notice that the list of colors to the right includes a warm and a cool of each primary (for example, both Winsor blue — cool, tending toward green — and French ultramarine blue — warm, tending toward purple). This allows you to create color temperature contrast even when using one basic primary. Having a cool and a warm version of each primary helps you mix complements without getting mud.

Also, keep an assortment of secondary colors (colors composed of two primary colors), including cadmium orange, an intense orange difficult to mix using other colors, and cobalt violet, another hard color to get by mixing.

It's a good idea to arrange your colors with the cool colors on one side and the warm on the other. Put your colors in the same place every time so that you won't have to hunt for them. You need to think about what colors you want to mix, not where to find your colors.

Be generous when putting colors on your palette — you need plenty of pigment to paint a watercolor, and digging and scrubbing for color while painting will only disrupt your thinking process.

A basic palette of colors, as shown below, contains (left to right):
olive green
Payne's gray
cobalt blue
Winsor blue
Hooker's green dark
French ultramarine blue
cerulean blue
Winsor green
alizarin crimson
cadmium red
cadmium orange
cadmium yellow pale
lemon yellow
cobalt violet
burnt sienna
burnt umber
Van Dyke brown
raw umber
raw sienna
brown madder alizarin

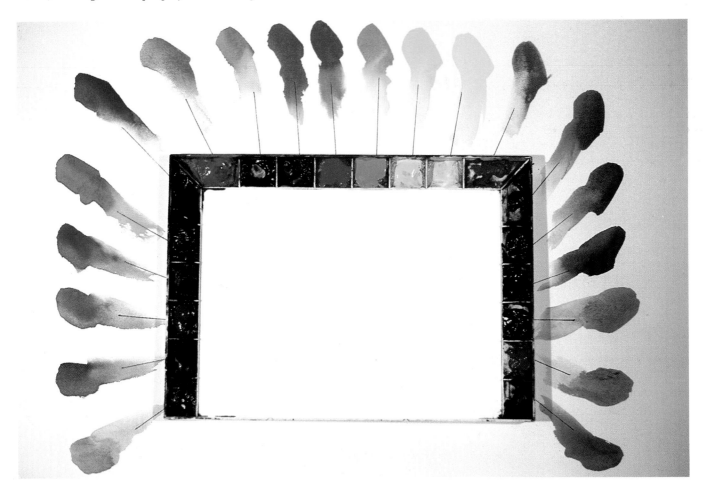

Materials for Pastel Painting

There are many different kinds and qualities of pastel sticks available today. Soft pastels give rich, paint-like textures. There are several good brands and, generally, you get what you pay for. Rather than buying a set of pastels, you may choose to put together your own set, including soft pastels from many different brands. Start with dark, middle and light values of about a dozen colors.

Easel

It's better to work on an easel than a table. On an easel the pastel dust falls away from the painting's surface. With a table, it just lies there getting in the way.

Drawing Board

Try a piece of ⅛-inch Masonite.

Masking Tape or Clips

Use a clip or piece of tape across each corner to hold the paper on the board.

Bristle Brush

This is handy for brushing pastel away if it needs to be removed. It works equally well on paper or sanded board.

Fine Sandpaper

This may be used to remove pastel on paper and at the same time rough up the paper so it is receptive to pastel again.

Selection of Soft Pastels

Keep a dark, middle and light value of each of the colors you choose. If you

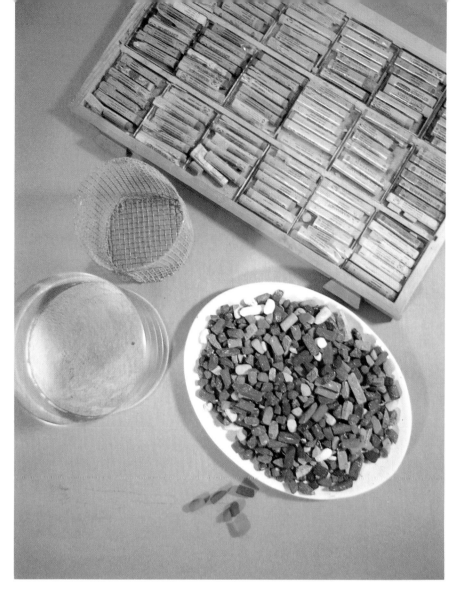

This shows pastels stored in drawers; pastels set out on a porcelain plate; a coffee can, wire basket and rice flour for transporting pastels; and a small group separated out to use.

start out with a small set, expand it so that you have a dark, middle and light value of each color in the set.

When you buy a new stick of color, cut a slit in the paper and break off a piece of pastel about a ½" long. Keep the pieces of pastel on a porcelain plate next to your easel. Store the sticks in a drawer until you need more of a particular color. Save the papers. They have codes on them identifying the hue and value of each stick.

Store and transport your pastels in rice flour. The pieces of pastel are placed in a basket made of heavy window screen. This basket in turn is placed inside a coffee can, and rice flour is poured over the pieces. The rice flour cushions them, preventing breakage during travel. To use the pastels, just sift the rice flour out, dump the sticks back onto your palette, and you're ready to work.

Methods of Application

Pastel can be applied with a tip for linear strokes, with the side for broad, flat strokes, or as powder, sprinkled on or applied with the touch of a finger. You can't mix pastel colors the way you can mix a liquid medium. Pastels can be mixed only by painting one layer over another. Pastel can be blended by working one stick of color into another, or by rubbing with a finger, stump or tissue. They can be moved around by painting into them with water or turpentine.

Removing Pastel

If the pastel gets too heavy, whisk some away with a bristle brush. Use this method on paper or board. Sometimes the pores of the paper become so filled with pastel that slick, shiny spots develop. What has happened is that the tooth of the paper has been crushed by repeated applications of pastel. The bristle brush won't help. These spots can be revitalized and the pastel removed by gently sanding them with a piece of light sandpaper. But don't use sandpaper on a sanded board. The sandpaper will remove its sandy surface.

Fixative

Fixative causes the light values to darken and the colors underneath to bleed through to the surface. Therefore, it is not wise to seal a finished painting with a fixative. If you are going to use fixative, use it only to seal coats of pastel you intend to cover with an additional coat. Instead of spraying a finished painting with a fixative, strike

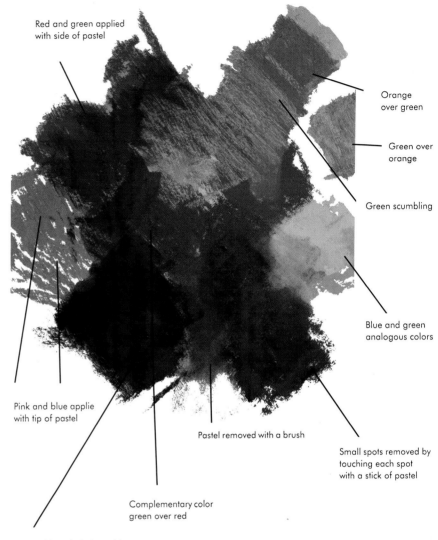

Red and green applied with side of pastel

Orange over green

Green over orange

Green scumbling

Blue and green analogous colors

Pink and blue applie with tip of pastel

Pastel removed with a brush

Small spots removed by touching each spot with a stick of pastel

Complementary color green over red

Small spots of board eliminated by touching with the little finger

the board several times on the back. These blows knock off any pastel that is loose enough to fall off later. If small open areas result, retouch these before framing.

Paper and Board

The pastel paintings in this book were done on Canson paper, etching paper or Masonite board. Of the Canson papers, the lighter brown or gray tones work well with pastels. Avoid the dark papers and brightly colored ones. The front side of the Canson has a screen-like texture that some artists find objectionable, but the back side is smoother. While any etching paper will work, try the texture of German etching. Tone the etching papers with additional washes of acrylic or casein.

Chapter Two
GETTING STARTED
Setting the Scene

An artist cannot paint without tools, and if you plan to paint still lifes, still-life objects are among your tools. You shouldn't try to imagine the shape of an object without having it before you, any more than you would paint without your brush.

Collecting Still-Life Objects

Finding still-life objects is one of the joys of painting. If you enjoy doing flo- ral or still-life paintings, you'll need an assortment of different objects to choose from when arranging setups. If you keep using the same things over and over, you will quickly become bored and so will your viewers.

What you collect does not need to be expensive. Antique stores often have broken objects that they will sell at reduced prices. An object does not have to be in perfect condition to be used in a painting. Collect an assort- ment of different-sized and -shaped ob- jects, especially vases in clear glass and different tints, both opaque and trans- parent. Collect metal objects and un- usual objects, such as garden tools and hats of every shape and gender.

As you select objects for your paint- ings, think about size, shape and color, but by all means let yourself be in- spired. There's nothing wrong with painting something many times if you enjoy it, but don't paint it just because

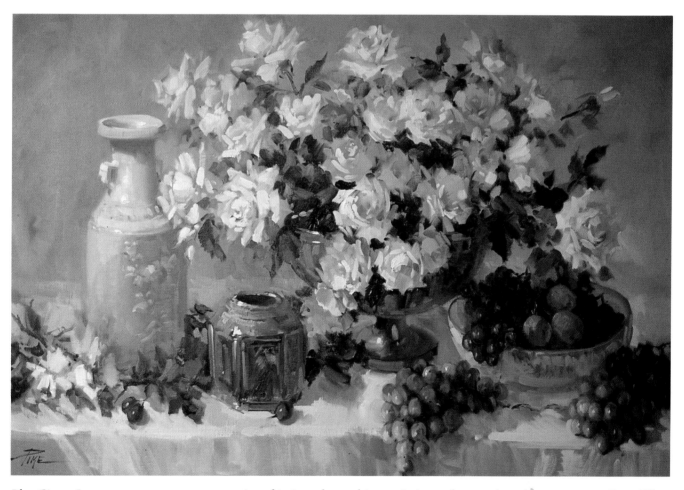

Blue Ginger Jar
Joyce Pike
24" × 30"
oil

Any object can be used in a painting as long as the values are correct. Joyce Pike successfully used several different objects in this painting by emphasizing some and understating others.

it is familiar to you. This is a bad habit and can keep you from growing.

Change the objects in your setup until you are anxious to get started. Plan for well-related shapes and color; it's more difficult to change a shape or color on your painting than to make your setup look right from the start.

If you decide to collect artificial flowers, be selective. Buy a few of better quality and buy from several different manufacturers. It's also a good idea to mix real and artificial flowers. This will help your bouquet look more realistic.

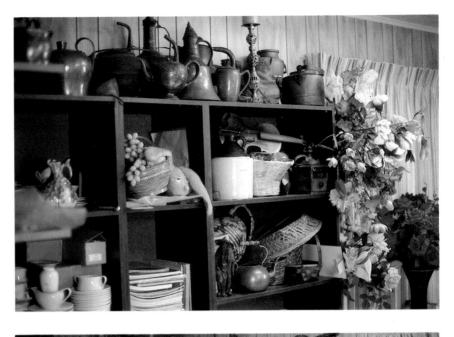

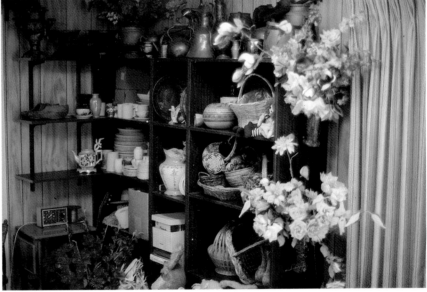

These two photographs show Joyce Pike's studio storage area. You can see the variety of colors and textures Pike has to choose from when setting up an arrangement for a still life. Her collection helps inspire her to paint.

Arranging the Setup

Every good painting starts with a good idea. Inspiration is important to the success of a still life, but inspiration alone isn't enough. The arrangement must be based on shape, color and balance. If you are using flowers, let the flowers take center stage. You can do this by making sure that all the other shapes are the right color and value for their intended spot. The light source is also part of the composition. Where and how much light is striking influences the balance. Cast shadow is part of the lighting. Without the light, the shadow doesn't exist. The stronger the light, the darker the shadow. This dark-and-light pattern is the most important part of any painting and should be considered from the very beginning. Again, don't guess. Have everything well planned before you start.

All three examples shown here could make good paintings. However, Example 1 seems a bit busy. Example 2 has good balance, but it is not quite as appealing as Example 3. The key word is *balance* to make everything work.

Example 1. *This has good color, but the objects are too far apart. The purple cloth at the left tends to make things a bit busy by covering up a needed resting spot for the eye. The small, brass coffeepot/server is lost in shadow.*

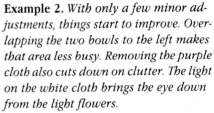

Example 2. *With only a few minor adjustments, things start to improve. Overlapping the two bowls to the left makes that area less busy. Removing the purple cloth also cuts down on clutter. The light on the white cloth brings the eye down from the light flowers.*

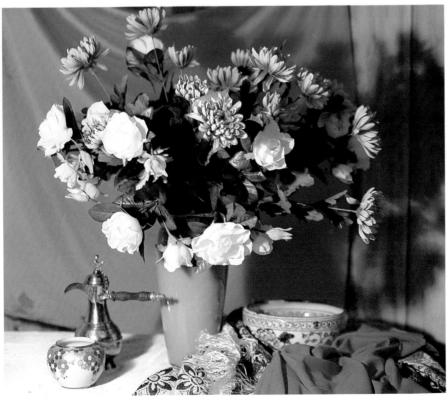

Example 3. *When the blue-and-white bowl is moved to the right of the flowers, it makes a nice contrast with the dark spot behind it. Moving the coffeepot to the left, behind the small bowl, and allowing the handle to overlap the vase help break up the straight line of the vase. All the objects now balance better for several reasons. The dominant colors are blues and violets, but a bit of the complement can be seen in the decorative drape on the table. The small colorful bowl to the left brings both dominant and complementary colors to the left edge of the canvas. The larger bowl adds light and design in the dark area where it is needed to continue the patch for the eye.*

Design and Composition

Flowers in a bouquet are like actors on a stage: Some must command more attention than others for a balanced performance. Design means making sure all the elements are placed in the correct spots to balance perfectly on the canvas. Either the darks or the lights should predominate; they should not be in equal proportion. The midtones need to support the darks and lights, the values merging in some areas to offset where the darkest dark and the lightest light come together to make the focal point. The strongest contrast will draw the eye first, before it starts its visual trip through the canvas. Everything needs to work together to make a perfect balance.

Design for The Porcelain Pitcher

The plan for this composition was to use a limited number of lilies with no supporting flowers. The busy background was chosen to contrast with the stiff, harsh look of the lilies. Placing the pitcher in front of the white vase helped to balance the long, narrow canvas. The dark pattern of the large green leaves needed another dark for balance, so the ginger jar was placed behind the white vase. If the ginger jar had been brought to the front and the decorative pitcher to the back, the dark vase would have drawn the eye toward the bottom of the canvas.

A halftone was placed on the lower left corner to break up all the light on the tablecloth. The cast shadows on the right side break up the negative space there. Remember, cast shadows are a very important part of the painting. But don't get too complicated with shadows at first.

The painting is warm and high key, more light than dark. The midtones

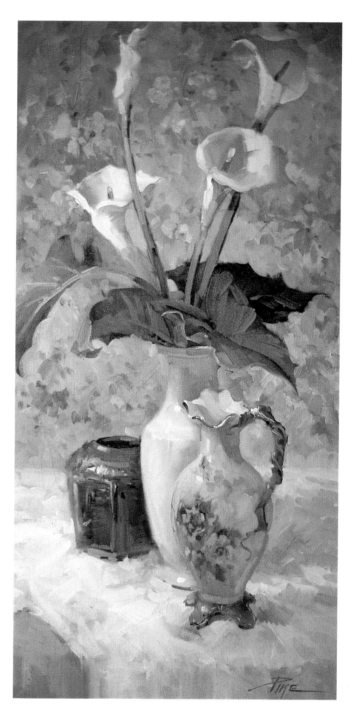

The Porcelain Pitcher
Joyce Pike
30" × 15"
oil

The busy background here offsets the stiff, formal lilies.

Basic Still Life Techniques

play a more important part here than in most paintings because of the decorative midtoned background. Even though the pattern on the pitcher is subtle, it helps draw the eye back from the busy background to the lower front of the canvas. Everything in a painting should have a purpose. Spend time planning every element before you start to paint.

Design for Tulips and Sweet Peas

A good painting need not be a busy one. Here, each beautiful, fresh tulip is shown at a different angle. The tulips to the left bend gracefully to allow the eye to travel downward from the center tulip. The dark vase is softened by the wild sweet peas, which are of the same dark value and color. The white cup with the cobalt blue pattern provides variety and also works to break up the hard edge of the very dark blue vase. The tiny blue duck in front of the vase varies the hard edge where the dark vase sits on the white tablecloth. The two full-blown tulips in the direct center show foreshortening. This gives the illusion of three dimensions on a two-dimensional surface. The two petals from a spent blossom and the draped sweet peas help complete the design and break up negative space. The painting is simple yet effective.

Let's talk briefly about color. The overall hue here is blue, with blue-green and blue-violet as adjacent hues and the yellow of the tulips as the complement. It's easy to see that the painting is high key. The dark purple of the vase works as a strong dark and also supports the dominant hue. The overall look is cool, with just enough warmth on the tablecloth to break up all the cools.

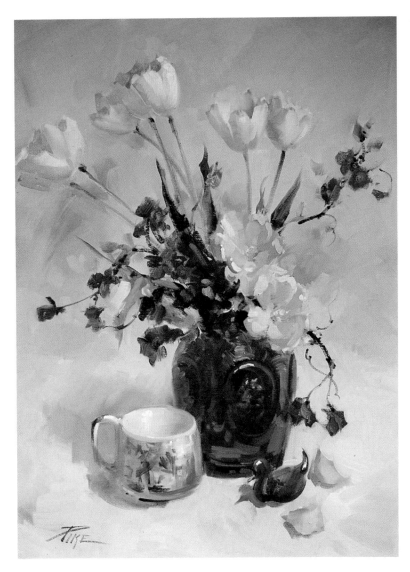

Tulips and Sweet Peas
Joyce Pike
24" × 18"
oil

This simple composition is fresh and vibrant with its bright complementary colors.

Background and Negative Space

Every inch of the painting has to work for you. You can't concentrate just on flowers and ignore the area behind them or in front of them. Neutral grays may be the most important colors you'll learn to mix. If a table edge shows, it is part of your composition and has to be carefully considered. If a background is flat and all one value or color, you will need to fill part of this area with flowers or foilage to make it work. These three finished paintings illustrate this space-filling problem.

Colorful Fruit and Flowers

When artist Joyce Pike had everything ready to go on this setup, she put a 24″ × 30″ canvas on her easel. Then she just couldn't get inspired. She says that she never seems to get as excited about painting smaller paintings as she does about painting big ones. So she changed to a 30″ × 40″, her favorite size canvas. Now she had another problem: There was more negative space in the background. What to do? The flowers were very colorful, so she used several colored grays in the background and allowed the brushstroke to show slightly. If she had used a neutral gray background, the flowers would have jumped out with all their color, which was not her intention. She wanted to keep it subtle, so she placed stronger color in the background.

Happy Wanderer

This little 24″ × 18″ painting was done as a demonstration for a class. The matilija poppies and wisteria are a beautiful combination. The floppy look of the poppy and the graceful draped look of the wisteria go together very well. The background is gray and almost flat, but the flowers take up most of the picture plane. It was not necessary to show brushstrokes or more color in the background here. The one small figurine left too much negative space on the table, so Pike draped the wisteria down to touch the table and scattered a few wisteria blossoms on the tablecloth. There are many ways to fill negative space. Those spaces may end up being relatively empty or full of objects, but you must make sure they work by planning your composition well. Don't leave it to chance.

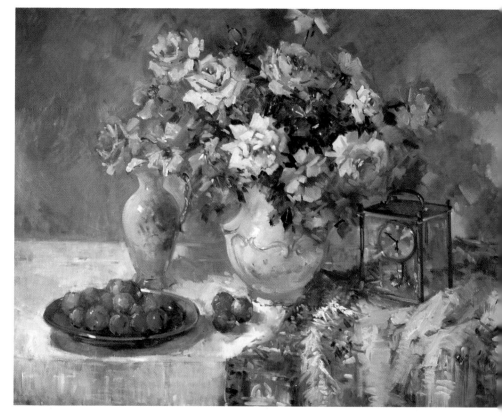

Colorful Fruit and Flowers
Joyce Pike
30″ × 40″
oil

In this painting, the colorful background harmonizes with the brightly colored roses.

Venetian Glass

Here, we see flowers going to the edge and even a few going out of the canvas. When this is done, the background is almost nonexistent, evident only where it is seen around or through the flowers. The table could have caused problems. If the decanter and liquor glasses had been too close to the edge of the table, it would have made the painting appear to be cut down from a larger size. By placing the colorfully painted vase to the left, Pike could draw the eye down to the glasses — again, filling negative space. A little empty space is necessary. There should always be a spot somewhere, even if it's small, where the eye can go for a place to rest during the trip through the canvas. If composition is working properly, your background and negative space will be essential parts of that composition.

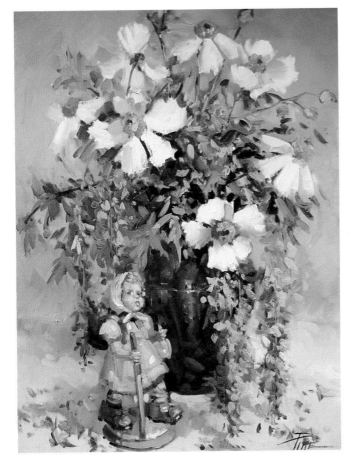

Happy Wanderer
Joyce Pike
24″ × 18″
oil

The flowers take up most of the picture plane here, so it wasn't necessary to add much to the background.

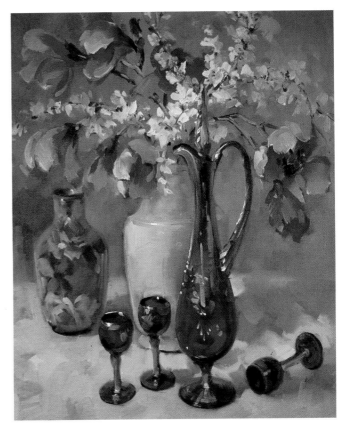

Venetian Glass
Joyce Pike
12″ × 9″
oil

In this painting, the background was not a problem, but the glasses were arranged carefully on the large negative area of the tabletop.

Building a Stage

The photos on this page show how to use an ordinary cardboard carton to construct a simple stage for your floral arrangement or still-life setup.

Cut the carton so as to leave the bottom and two adjacent sides. The sides become the background, and the bottom is the stage for your floral arrangement. If your box is a bit small, it's easy to extend the sides or the bottom with matboard or craft paper. Next, select the props to include and decorate the stage to your liking. You are the stage manager.

Place the box so the light strikes one side of the background and the other is in shadow. With this setup, you can arrange the objects so their shadow sides are seen against the sunny plane of the background, and the sunny sides of the objects stand out against the adjoining dark background.

This basic principle of light against dark and dark against light makes each form easily recognizable. You can achieve other lighting effects by simply putting a cover across your stage setup.

Once everything is in place, photograph your arrangement. Time goes by so quickly when you paint that the flowers may begin to fade before you know it. With your photograph for reference, you have the security of knowing your arrangement will last as long as you need it.

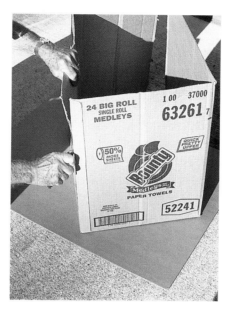

Use a sharp knife to cut down along opposite corners of a large cardboard carton.

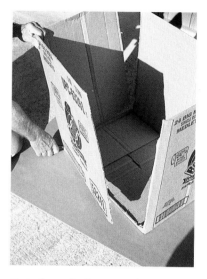

Cut along the bottom edge to remove two adjacent sides of the box. The remaining two sides and bottom of the cardboard carton become a stage for your floral arrangement.

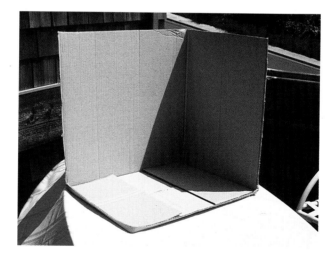

Place the stage so one surface faces the light and the other is in shadow. It is now ready to be decorated with your floral arrangement.

Here (right), a blue mat board was added for more color and a piece of fabric was draped across the back. Next came a jug of dried leaves. The blue leaves repeated the color of the floor, and their shadow made an interesting pattern across the jug's surface. Finally, a vase of roses was added in the foreground.

Here (below) is the painting by Jan Kunz done from this stage setup.

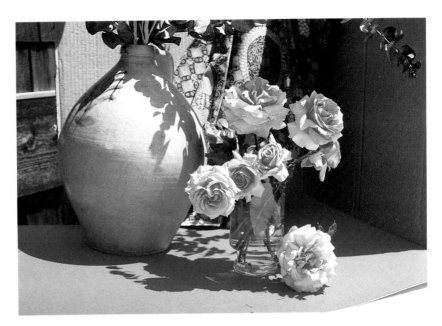

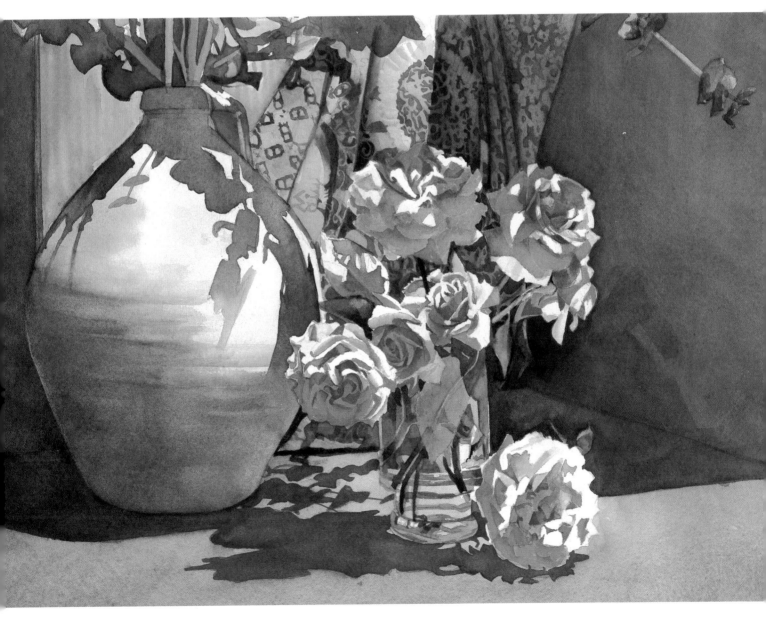

Starting Out With Oil

For this project, you will work from a simple still life you can set up on a table. Use a floor or table lamp for a strong light effect. Prepare or obtain some 12″×16″ or 14″×18″ painting panels. You will also need bristle brushes, a painting knife, an oil cup to hold paint thinner and some wiping rags. Titanium white and burnt umber are the only oil colors that you will use, since you will be working only with light and dark values.

Working With Two Values

The first part of the project will be wet-into-wet painting without any preliminary drawing. This will help you become accustomed to using your brush with oil paint. This project is a study, not a finished painting, so detail and finish are not important.

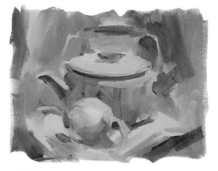

For your still life, select simple items and arrange them with some drapery as a background. Use a strong light source from one direction for strong shadow areas. A still-life box can be made as shown on page 20.

On your palette, premix two mounds of oil paint in a dark and light value. Use burnt umber and titanium white.

Light ground, adding dark

STEP 1
Brush the lighter paint over the panel's surface using a little painting medium to thin the paint.

STEP 2
Brush in the darker values using the darker paint. Be sure to wipe your brush frequently with a rag.

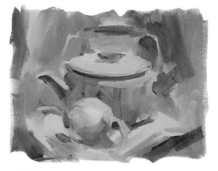

STEP 3
Put in more darks and then some lights to correct the shapes. Blend some areas together for softer edges.

Dark ground, adding light

STEP 1
Brush the darker paint freely over the panel's surface, covering it thinly.

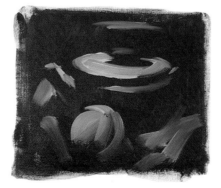

STEP 2
Brush in the lighter values as you see them while squinting.

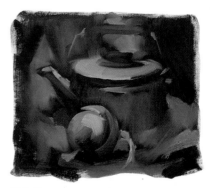

STEP 3
Put in more lights and blend some areas together. Use darks to correct edges.

Working With Three Values

To show full form or modeling, you must have three main divisions of value in your painting. These are the dark, middle and light value ranges. For this part of the project, premix these three values using burnt umber and white. Make sure that you have good divisions between them so that they stand well apart from each other. Work from the same still-life setup or try changing the light direction for a different lighting effect. Remember to squint as you study your subject so you can accurately judge its value relationships. Compare important edges by aligning them vertically and horizontally against straight lines. Use a narrow brush handle as a guide. This is only a study for practice; don't be concerned if it looks unfinished.

Add a third, middle tone, to the two values you've been using.

STEP 1

Start working directly on a panel with a small bristle brush and thinned-out burnt umber. Try to put in just the large simple shapes, ignoring all the little details. Compare important edges against each other.

STEP 2

Paint in more lines to strengthen form and work in some darker values with an oil wash. Squint while looking to see these main shadow areas.

STEP 3

Brush in some of the dark- and middle-value paint to begin to build form. Then, using the lighter paint, find some of the important edges.

STEP 4

Match the main value areas and paint them in. You may have to blend some of the premixed paint for certain areas. Wipe your brushes out frequently.

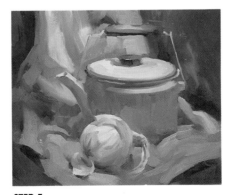

STEP 5

More controlled mixing of values and adding good edges where needed help to develop the form. Remember not to overbrush. Leave your strokes alone.

Assemble a Still Life

In this project, you will literally assemble your still life as you draw it. You will need an Ebony pencil and a sheet of 18″ × 24″ newsprint paper. (Although this demonstration is in pencil, you can do this same exercise in any medium.) Depending on the complexity of the objects you chose, you will need about twenty minutes to finish this exercise.

Select two or three objects and place them on a table or a stand, and draw a contour of them. Find another object, place it with the others and draw it on the same drawing. Add another object and draw it. Continue adding more and more objects until the composition is full. Notice how the shapes of your drawing interlock. Watch how the lines around each shape help define the shapes around it.

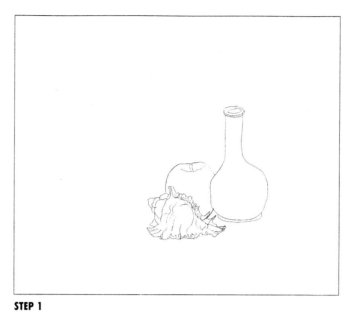

STEP 1
Draw two or three still-life objects.

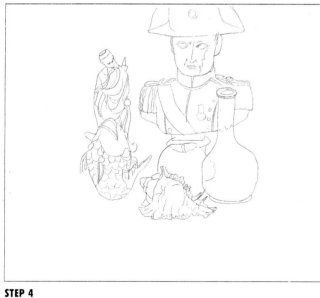

STEP 4

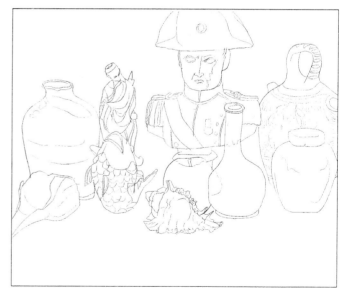

STEP 5

STEP 2
Add another object and draw it.

STEP 3
Continue adding more objects and drawing them one by one until your drawing is complete.

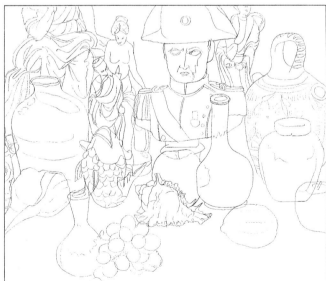

STEP 6

STEP 7
Stop when you have drawn everything in your field of vision as limited by the edge of the paper.

DEPICTING FORM
Painting Three Dimensions

A major task for any artist is to develop the skill to render shape and form accurately. For the still-life artist, rendering the relationship of shape to shape and maintaining the balance of proportions in a painting are equally important. Here are a few exercises to help you see and paint shape, form and a complete composition.

Massing In Shape and Gesture

For the following exercise, you'll need a medium-sized brush, a tube of either burnt umber or Payne's gray, and a canvas or canvas board. Place four or five objects on a table within easy sight of your easel or drawing board. The items don't necessarily have to relate to each other and can be as diverse as a shoe, frying pan, hat, coffee cup, apple or bottle. Choose materials that are complementary in shape, for instance, a busily patterned running shoe positioned beside a white ceramic coffee mug. Illuminate the setup with an *indirect* source of light. An overhead fluorescent lamp is ideal. Less effective but still workable is natural light originating from either a window or skylight. Avoid using direct sunlight or any other powerful light source that casts strong shadows or splits the forms into harsh patterns of light and dark.

Exercise

Thin a generous amount of paint with medium and daub a small mark no bigger than a penny anywhere on the canvas or paper. This breaks the tension of assaulting the formidable, untouched whiteness of the painting surface. It's surprising how many students—and a good number of professionals—can be overly timid about making their first marks on a clean canvas or fresh sheet of watercolor paper.

Beginning with whatever object in the grouping strikes your fancy, proceed to mass in its overall shape. Start with the innermost part of the form and push the paint outward toward the edges. Avoid sketching any preliminary guidelines. Work *directly* with your brush. Use a value approximating middle gray and apply plenty of thinned pigment. Draw as you paint, trusting your sense of proportion, using the edges of the paint mass to define the outline of the object.

Work with the single, middle-gray tone, disregarding any value changes, highlights or cast shadows you may observe. Your only concern is to capture the shape and gesture of the subject. If you mistakenly paint beyond any of the form's boundaries, wipe off the area with a paper towel or tissue and restate the passage more accurately. Complete all five objects, and remember you're just painting an exercise, not a masterpiece. Each sketch shouldn't take more than ten minutes to finish.

Critique

Now step back and study what you've done. Are the proportions reasonably accurate? Is the object recognizable? If not, try a few more sketches. Although this first exercise was concerned with just shape and gesture, a number of objectives have been achieved. First, a recognizable silhouette has been created. Second, massing-in has replaced the need for a preliminary drawing. Finally, the finished piece has conveyed a sense of substance and gesture.

This may seem like a very basic exercise, but think about how many art forms of the past were based on the idea of massing in the shapes of objects. The ancient cave paintings of animals in Lascaux, France, the decorative paintings on Greek pottery, and the woodblock prints of such Oriental artists as Hokusai and Hiroshige, all reveal the graceful power inherent in the art of shapemaking. In our own century, Henri Matisse and American impressionist Maurice Prendergast are just two of the many artists who, after learning traditional painting methods, intentionally reverted to the silhouette as a means of personal expression.

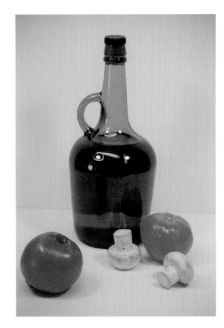

Photograph of the subject.

*Silhouette of the subject massed in with
thin washes of burnt umber.*

Defining the Form of an Object

This lesson will deal with lightening and darkening the tones of paint to give the subject a feeling of form and tactile solidity. This principle seems to contradict the usual "paint what you see" attitude, but visual painting is only one of many ways an artist can approach a picture.

Showing the form of an object tactilely means using various gradations of tone and color to guide the viewer's eye over the surface of an object. Visual painting, on the other hand, generally focuses entirely on the more two-dimensional effects of light and color.

Exercise

Rearrange the objects used in the last exercise or replace them with new ones. Add white to the burnt umber or Payne's gray already on your palette. Avoid being skimpy with your paint. Oils are meant to be used opaquely, so right from the start, get into the habit of squeezing out plenty of pigment and applying it with generosity. Now brush in a pale, flat wash to approximate the shape of the object. *Use your sense of touch* rather than the visual impression of what you see. Reach out in front of you and feel one of the objects. Explore the form with your fingers, letting them feel the terrain, establishing points nearest and most distant from you. Imagine that you are a mapmaker on an expedition, responsible for recording the geography of the location. What

form feels highest? What areas go under, around and back? What parts feel deepest? Take as long as you need to become familiar with the surface characteristics of the object, retracing steps if need be, until the form is thoroughly clear in your mind.

Now pick up your brush and retrace your journey on the canvas. The light tone already painted will be reserved for the portions of the object closest to you. Start with the parts of the form that begin to recede, painting them and all the other receding areas of the object a slightly darker value. Keep darkening the values as you paint those forms farther from you. Remember this rule: The closer a form is to you, the *lighter* the value you use to paint it; the farther a form is from you, the darker the value you use.

Critique

Complete all five objects in a similar manner. If done successfully, the items in your painting will appear not only to be solid and convincing, but also to be illuminated by a light source positioned directly where your hand reached out to touch the objects.

Study your completed exercise and notice how each sketch takes on an almost sculptural solidity. The reasons for this are the tactile method used to render the forms, as well as the disregard of any conflicting tonal changes caused by the actual light sources. Your sketches should appear to be lit by a

source emanating from your outreached hand.

Beyond Simple Shapes

Painting three-dimensional form is a bit more complicated than defining simple shapes. You create the illusion that an object is round or solid by showing how the values change as light falls on the object.

Rounded Object

For a rounded object, there are five value areas to portray. The brightest is the area where direct light is falling, the section that is farthest from the light source. Fourth is reflected light in the shadowed area; this is usually seen as a lighter edge on the outside of the shadowed area. The fifth and generally darkest value is the cast shadow. This is the area around the object where no light is falling, because the object is blocking the light rays.

Objects With Flat Planes

On a shape with flat planes, the planes facing the light source will be light, with the lightest values closest to the source and the rest of the plane becoming slightly darker as it moves away from the light. Planes facing away from the light source will be darker. How much darker depends on how much reflected light falls on them. Those facing completely away from the light will be darkest.

Photograph of the subject.

Paint the part of the object closest to you the lightest. As the form recedes, paint the areas progressively darker until you reach the most distant edge.

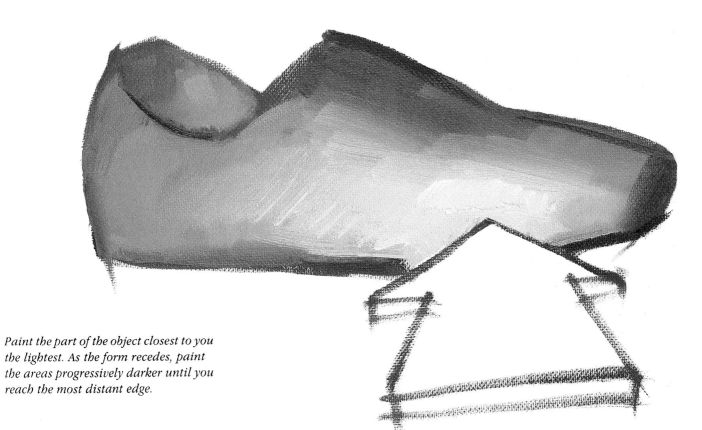

Painting Groups of Objects

Once a mastery of shape, gesture, tactile solidity and home values is acquired, you should be more than well equipped to tackle this next exercise, which involves clustering items together and painting the grouping as a unified whole. Your objective is to unify the various forms in your setup into a single pictorial statement.

Getting carried away with the *parts* of a picture is a common painting error. Students and professionals alike often become engrossed in a particular object in their painting, only to step back and see their precious effort stick out like a Rolls Royce at a construction site. Remember, no matter how beautifully you paint an object, it remains a mere study until it is artfully incorporated into a composition.

Exercise

Choose four or five objects of various shapes and sizes with different home values and arrange them in a group. Step back and study the setup, overlapping and repositioning things until the forms appear unified. A large jug or serving tray, for example, placed beside or behind a couple of small items like a piece of fruit, a tube of paint or a can opener will give the subject scale and variety. Avoid lining up items evenly in a row like a picket fence. Overlap things; stack one object on top of another; turn a form on its side or even upside down if it makes the composition more interesting.

Begin painting the setup relying on touch more than sight. Try to work on all the objects simultaneously. You might start with the near edge of one form, move to the far side of another, and then jump to the middle masses of a third. Keep the background simple. Little or no background additions are needed because the canvas has already been toned a light gray.

Concentrate on getting the effect of the grouping as a *whole* rather than focusing on any one part. Disregard any cast shadows, painting only the tones your sense of touch directs you to make. The completed painting should appear as a unified cluster of objects against a nearly neutral background.

Critique

Study your composition. Do your objects combine to create an overall shape with a pleasing silhouette, or have you focused too much on details? Which attracts your eye — the composition of the group or isolated items? Strive for balance. A group of forms as well as individual objects can be masterfully painted, contributing to the integrity of the overall composition.

Whatever objects you choose to paint will appear only as a collection of parts until you compose them into an interesting arrangement.

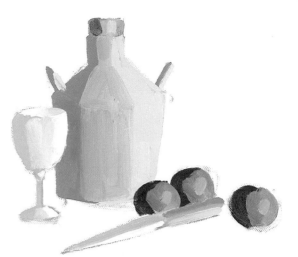

Keep rearranging the objects until the overall shape takes on an interesting silhouette.

If you get carried away with the details, take a break and view the picture from a distance. Remember, it's the grouping as a whole that counts, not any one individual part.

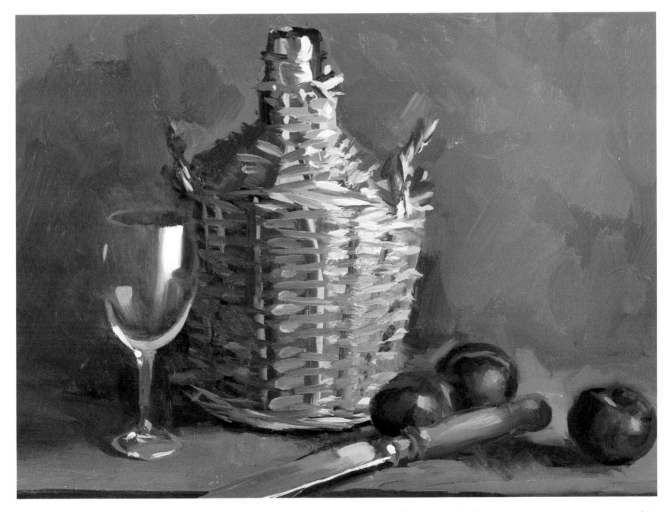

Still Life With Plums, Knife, Glass and Bottle
Charles Sovek
12" × 16"
oil on Masonite
collection of Zolton and June Henczel, Norwalk, Connecticut.

The lay-in for this work was done exactly the same way you were instructed in the exercise. Artist Sovek spent an hour positioning the objects until he was satisfied with the overall shape. Notice how the overlapping gives a composition interest.

Painting a Whole Composition

This exercise, covering pages 32-35, includes the background as part of your subject. Backgrounds tend to be the forgotten stepchild of far too many student compositions. By giving a background the same careful attention lavished on the objects in a painting, you'll find your picture achieves a unity that can transform an ambitious study into a far more complete artistic statement.

Exercise

For this exercise, you'll need an assortment of objects, an unpatterned piece of cloth or drapery, and an empty cardboard box into which the items will be placed. Trim off the top and two adjacent sides of the box. Secure the drape to the top edge of one of the two remaining sides, positioning the fabric down the side and across the bottom of the box. If you don't have a box, push a table against a wall and fashion the drape in a similar position by tacking or taping it against the wall and letting it drop down and cover the table.

Ruffle the cloth a little until some interesting fold patterns break up the flat monotony of the material. The middle gray home value of the drape will provide just the right foil for showing off the lights and darks on the other various home-valued forms. Place the objects in the middle of the setup, rearranging and overlapping them until they form a unified whole.

Repeat the same painting procedure as in the two previous exercises. After massing in the shapes of the objects and a few dominant folds, begin to model and solidify the various forms. Think of your brush as a sculptor's tool incisively carving the broad planes of the subject and then refining each item with more detail as the picture takes shape. Treat the forms of the drapery the same as the objects, using your sense of touch to show where the values lighten and darken. By approaching your setup from either side rather than the front, the play of light to dark across the forms will appear more interesting and three-dimensional. Continue painting until the objects and drapery appear convincing and the entire surface is covered.

Critique

Does the background of your composition overpower the objects in the foreground, or have you achieved a satisfying balance? Do your forms appear solid, contributing to an integrated composition? Have you lost yourself in details or have you painted boldly, capturing the strength of your forms? A continued study of objects and drapery will add strength and drama to your still lifes.

A cardboard box trimmed of two of its sides and a piece of drapery are all that's needed to make a still-life backdrop.

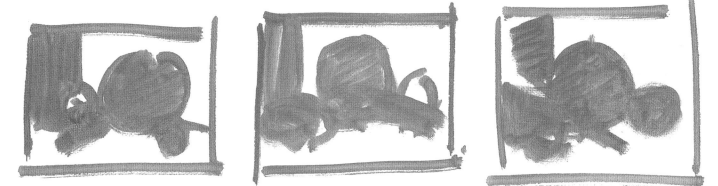

A few preliminary doodles such as these can quickly reveal the best arrangement to choose from.

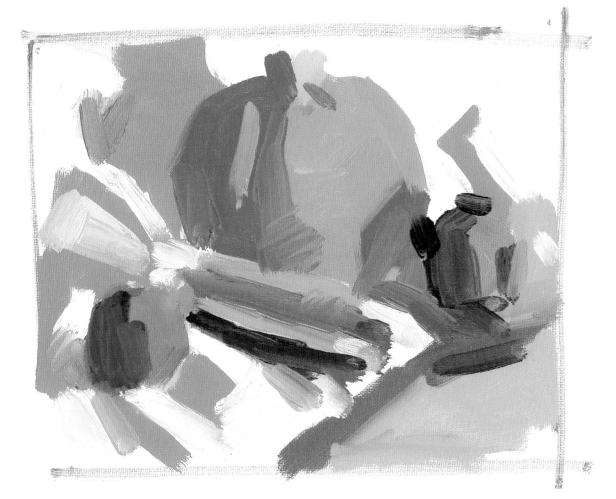

Lay in bold patterns of value until the painting begins to take shape. Working with as big a brush as you can comfortably handle, reduce the subject down to a large mosaic of shapes and values.

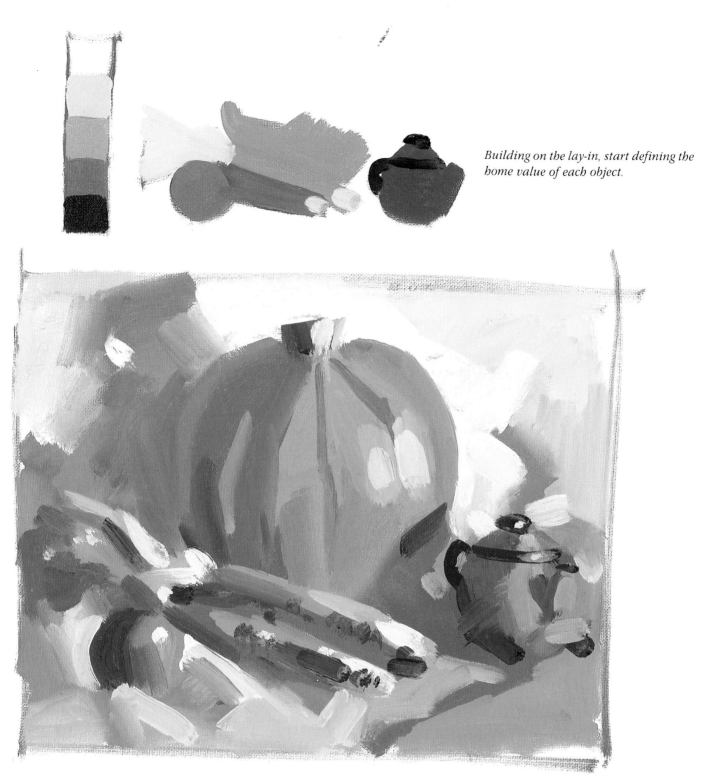

Building on the lay-in, start defining the home value of each object.

As the painting begins to take shape, start modeling each of the individual items. The painting is complete when the objects appear solid and the composition unified.

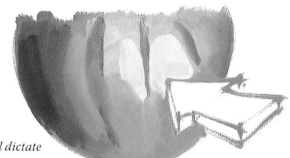

Remember, your light source will dictate how the forms are modeled.

Basic Still Life Techniques

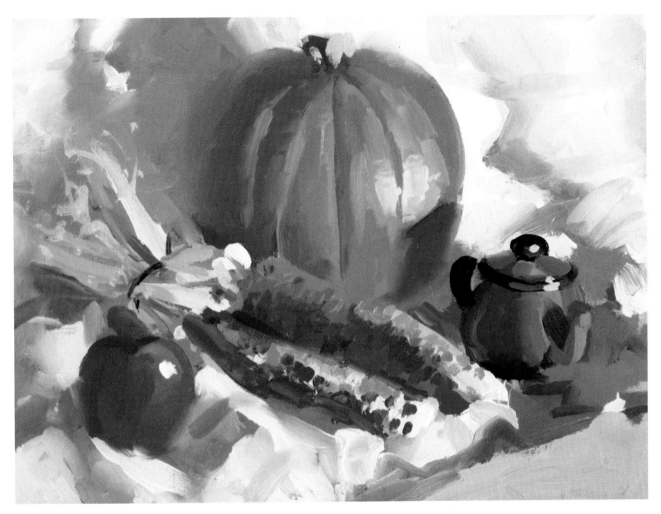

Autumn Still Life
Charles Sovek
16" × 20"
oil on canvas
collection of Armand de Grandis,
Torrington, Connecticut.

A classroom demonstration that worked. Sometimes they don't! Painting an entire composition requires constant attention to the combined effect of the overall masses. What holds this busy picture together is the strong pattern of light and shadow that weave in and out of the various forms. Notice the use of soft edges in the shadow and how they make the objects appear to melt into the background. This device helps the overall unity and defines the roundness of the forms.

REVIEW YOUR PROGRESS

L ine up all four exercises in front of you and study them to make sure you thoroughly grasp each of the principles presented. You have just solved many of the basic problems encountered by artists in still-life painting, as well as in landscape, interior and figure work. You'll be using these basic building blocks of painting again and again, so be sure each one is clear in your mind.

Doing a Preliminary Drawing

When a setup contains several objects of different size and shape, it is of utmost importance that every object be drawn correctly. This is not the same as loading a composition with detail. Angles and ellipses must be drawn with care. Your viewers will notice if somehow your painting doesn't seem "right." The preliminary drawing is the place to establish perspective and placement before committing yourself to painting.

A clock was chosen as one of the objects to show you how carefully each line and angle is drawn. Every elliptical shape on each object has been drawn as it would be seen from eye level. Once eye level has been established, all ellipses will become deeper the farther from eye level they are. This is clearly seen in the drawing. Each object is drawn in correctly to make sure enough space is allowed for all of the other objects. Each object or flower in a still life can be simplified to one of the basic shapes, such as a circle, square or triangle. The ellipse is probably the most important shape for the still-life painter to master.

Drawing for Black Antique Clock

After suggesting the placement of objects with light washes, Joyce Pike started this drawing by building a box in perspective where the clock was to be placed. Then she drew a plumb line through the center of the area where

Photograph of the setup.

Adjust your drawing until it is right. And watch those ellipses!

the vase would be drawn and drew the foreground dish, checking the measurement of height relative to width. This gave her the correct angle for placing the ellipse. The dish has the deepest ellipse because it is farther from eye level.

Pike measured width against height by standing in front of the subject, holding her brush out straight and horizontally and locking her elbow to be sure she didn't move—even a tiny movement could have given an incorrect reading. She held her thumb on the brush handle. From the tip of the brush to where her thumb was placed gave the width reading. By turning the brush and taking a reading of height without moving her thumb she could see how much smaller the measurement of height was relative to width. This is called a *rule of thumb* (that's where the old term came from). After correctly building the box for the clock using two-point perspective, Pike then found the center of the box by drawing an *X*. Once she located the center she knew exactly where to place every part of the clock. This drawing procedure will make even the most intricate object easier to draw. The flowers were not drawn as individual shapes at this time, but the suggestion of their placement was important for color and value. Not so with the still-life objects; they had to be carefully drawn right from the beginning.

Black Antique Clock
Joyce Pike
40″ × 30″
oil

A solid painting begins with an accurate drawing.

Chapter Four

LIGHT AND SHADOW VALUES

A Strong Foundation

If there were merely two concepts that you should remember in making better drawings for better paintings, they would be *shapes* and *values*.

We discussed ways to depict form in chapter three. In this chapter, we will begin learning about tonal values, which are simply the lights and darks in your compositions. These are the structures on which a painting is built. If you are working with a drawing medium that makes blacks and shades of gray, you are working with tonal value. A black-and-white photograph is an image that also shows only tonal value. All the different colors have been changed into grays.

Learning to work with tonal values involves two different things. First, you have to learn how to see colors and interpret them as shades of gray on your paper, the way black-and-white film does. Second, you have to adjust and modify those values so your drawing is both clear and interesting.

To begin, we need to think about one of the properties of color. Color has three dimensions:
- Hue—the color's name, such as yellow, red, blue, etc.
- Intensity—its relative brightness and clarity or dullness
- Value

Some colors are always lighter in value than others. For instance, on the spectrum of colors seen through a prism or in the rainbow, yellow is lighter than red, but red is lighter than purple. Any two colors can be compared to see if one looks lighter than the other in this way.

When translating the colorful world we see into values, you need to identify the lightest color and make it white or near white in your drawing, and identify the darkest color and make it black or near black. All the other colors will then be rendered as lighter or darker grays in a range or scale between the lightest and darkest.

The key to this process of rendering color into value is to make contrast comparisons between any two areas of value. This becomes automatic very quickly and requires little conscious thought.

In the following exercises, you will practice looking at colors and translating them into various shades of gray. However, since our eyes see more subtle differences in color than you could ever hope to reproduce exactly with any drawing materials, you will need to do more than just copy the values you see.

You will have to make changes in the values you see to make your drawing clearer and more appealing. Some darks will need to be darker than they actually appear, and some lights will have to be lighter.

Your goals in adjusting the tonal values are to make the drawing clearer, to enhance the illusion of depth and to strengthen the composition. Let's look at each in turn.

Make Your Drawing Clearer

The key to all of these goals—clarity, depth and strong composition—is contrast. Wherever two shapes are adjacent, there should be sufficient contrast in tonal value to make it clear which shape is which, or which shape is in front of the other. If two adjacent shapes are drawn with the same or close to the same value, the contour edge between them will be very difficult to see. The two shapes will appear to merge as one and the viewer will likely become confused.

In nature, or in the subject matter you are drawing, you may often see two forms that are very similar in value but different in color and texture. These differences make it easy for the eye to distinguish the shapes. However, if you render them as shades of gray in your drawing, you won't have color or texture to make the differences easily seen unless you alter the values.

The drawing on the far left is confusing because shapes of the same value are adjacent. The one next to it is clearer because there is a distinct contrast along adjacent contours.

Remember this rule: Contrast at the contours creates clarity.

Which shape you alter depends on many factors, but it is often an arbitrary choice. One or the other has to be lighter or darker for the sake of clarity. Your decision may be based on the reasons given below for enhancing depth or strengthening the composition.

Enhance the Illusion of Depth

The tonal values in your drawing will also greatly affect the illusion of depth. You may remember from the paintings completed in chapter three that darker values seem to recede into the distance and lighter ones appear to advance. Although there are many exceptions, you can apply this general rule to the tonal values in your drawings. If you want to create a strong illusion of depth, make the closer things lighter and the farther things darker.

Following this rule will help you decide what shapes to make a little darker when you see adjacent forms with very similar values. Make the shape that you want to appear farther away darker.

Strengthen the Composition

Finally, tonal values play a major role in the composition of your drawing. Tonal values will largely determine how your drawing will be seen by the viewer. The pattern of lights and darks will determine what part of the drawing is seen first, and what parts will attract and retain the viewer's attention.

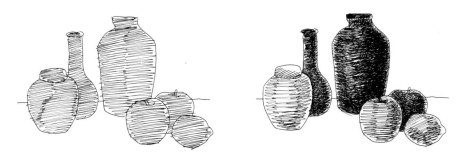

The drawing on the left lacks depth because the shapes are the same value. The one on the right has the illusion of depth because the more distant shapes are darker.

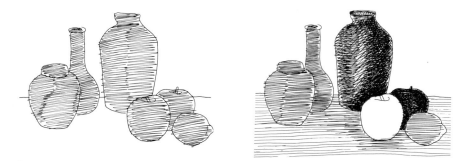

The drawing on the left lacks interest because there is no value contrast. The one on the right is more interesting because it has a definite focal point — the apples on the right, the area of greatest value contrast.

Value-Pattern Sketch

For this exercise, you'll need an Ebony pencil, one stick of soft (6B or 4B) graphite and white paper. Plan to spend thirty to sixty minutes developing this sketch.

The focus in this drawing is on the overall pattern of lights and darks in your subject matter. Every composition can be reduced to a flat pattern of lights and darks, and you must be aware of and sensitive to this pattern because it is the foundation of the picture's design.

It is not easy to identify and draw just the lights and darks because of the habit of seeing and wanting to draw things as *objects*. The left side of the brain naturally pays attention to the identity of what you are looking at as separate objects; it has no use for the tonal-value pattern. But it is the tonal-value pattern that is critical to the success of your drawing. As an artist, you should cultivate the habit of noticing the pattern of lights and darks independent of the identity of the objects.

Color must be ignored as well. Two objects, side by side, one blue, the other green, but of the same value, may need to be considered as one big dark shape. In this exercise, you are going to make small sketches of your subject by drawing *only* the lights and darks. Don't draw contour lines as boundaries of objects.

Like an out-of-focus photographic slide projected on a wall, your sketch should simply be a rough or generalized record of the overall pattern of lights and darks. It may help to look at your subject and *squint*.

In fact, your internal dialogue as you draw could sound like, "There's a large dark shape over here, and a light one over there, and here's a middle gray shape under that shape."

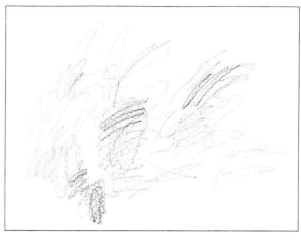

STEP 1
Begin with a loose, gestural indication of the entire arrangement of your composition.

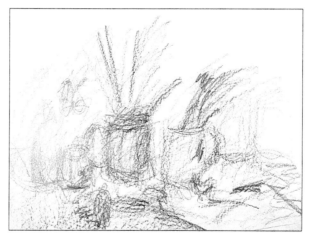

STEP 2
Scribble the lights and darks that you see. Don't draw distinct edges. Think of your subject matter as one big pattern of lights and darks.

STEP 3
Develop the drawing without outlining everything. Resist the urge to define edges. In the last moments of your drawing add only those details (and yes, edges, finally), that clarify your drawing. Be selective.

Gesture-Value Sketch

Use one stick of black Char-Kole and a sheet of white paper for this demonstration. You'll need thirty to sixty minutes to complete this sketch.

This is the same exercise as the previous one, except it is done with Char-Kole rather than graphite. Use a 1-inch-long piece of the Char-Kole on its side to make the darks in your drawing. Draw the lights and darks directly, without outlining everything first. Look for the overall pattern of lights and darks, and draw that, not the separate objects. Include only those details and edges that really make for a clearer, more attractive drawing. Don't over-work it.

Squinting is a very useful way of studying the overall value pattern of your subject. Squinting eliminates the details, making it easier to see the larger pattern of flat shapes of value.

As many artists have pointed out, there are very few lines in nature. What we render as lines on our drawings are only edges and borders, abrupt value changes and coloration. Nevertheless, we are in the habit of seeing these as line, and it is sometimes difficult to recognize their true nature.

This is a difficult exercise to do in the sense that it does not offer us the familiar and comfortable net of lines that we use to build and organize our drawings. It forces us to see things as a pattern of shapes of values. We must behold the larger pattern rather than looking at the details.

Tonal-value drawings without lines are real workouts for the right side of the brain!

STEP 1
Begin with a gesture of the entire composition. Think about drawing the bigger pattern.

STEP 2
Use the side of the Char-Kole to make broad strokes. Don't draw distinct edges. Don't draw one object or element at a time.

STEP 3
Refine the drawing, clarifying the shapes and adding smaller shapes.

Charcoal and Chalk on Gray Paper

You'll need an hour or more to complete this drawing, depending upon the complexity of the subject matter and the degree of detail desired. Assemble your materials first—one stick of soft white blackboard chalk or a 2B white Conté crayon and one stick of black Char-Kole, soft compressed charcoal or a 2B black Conté crayon. You'll also need a sheet of 18″ × 24″ gray charcoal paper, a plastic eraser and a kneaded eraser.

This exercise is the closest thing you will do to making a drawing that resembles a black-and-white photograph of your subject. Like a camera with black-and-white film, you are transforming color into value. Dark colors and objects in shadow become dark grays, and light or bright colors and objects in the light become light grays or white.

Unlike a camera, you are an intelligent agent capable of making subtle

adjustments in your drawing that will make it more interesting, clearer and more expressive than any mechanical or photographic process ever could.

You will need to simplify and generalize many of the differences in tonal value that you see. You will have to make judgments about how to reduce the myriad tonal values you see to a few

rather exaggerated value differences.

Your drawing should progress in three distinct phases: (1) Establish the composition. Include all the shapes in the foreground, middle ground and background as well. Take the lines all the way to the edges of the paper. (2) Draw the tonal pattern. (3) Add the details.

STEP 1

The Composition. *Begin with a gesture drawing of the whole arrangement of your subject matter, using either black or white chalk. Take the lines all the way to the edges of the paper; don't noodle around in the center.*

STEP 2

Tonal Pattern. *Begin establishing the shapes of light and dark. The Char-Kole and chalk can be scribbled over each other, letting the strokes blend on the paper into the shades of gray you need. Ignore detail. Your objective in this phase is to eliminate the gray of the paper by covering every square inch with grays of your own making.*

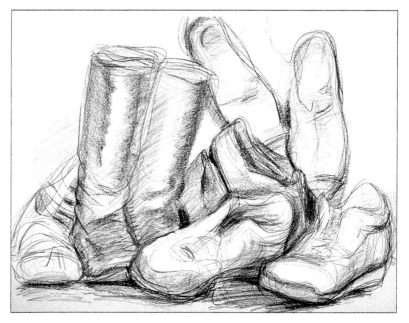

Basic Still Life Techniques

STEP 3

The Detail and Finish Phase. *Once the patterns of light and dark have been established, begin adding details. Step back from your drawing and look at it carefully. Ask the following: How can I make the shapes look three-dimensional? How can I create more depth? How can I make the drawing clearer?*

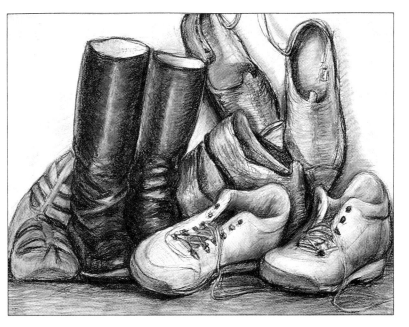

STEP 4

The Finished Drawing. *Add all the final subtleties, details and nuances.*

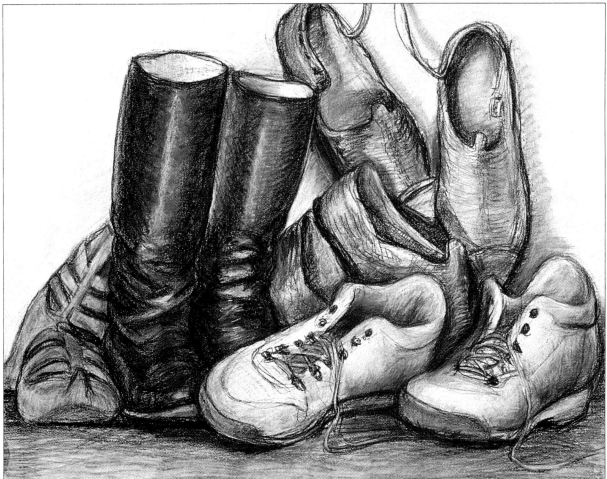

Comments: Although you may not really see any shapes that are a pure white or any shapes that are a true black, you will have to make some lights white and some darks black to distinguish what is closer to you and what is farther away.

The Right Value

As you saw in the exercises you just completed, no one value is always right for a bright highlight or a dark shadow. Values exist in relationship to each other. When you put two drawings or paintings next to each other, you may find that the value of the lightest light in one is as dark as the value of the shadow in the other.

In any particular painting, the lights will be light and the darks will be dark in comparison to the values within the painting itself. In a high-key painting, all the values will be light; in a low-key painting, all the values will be dark. Even using a partial range of values, you can model forms to look three-dimensional.

When you are modeling a particular form, it can be helpful to begin by laying in part of the lightest light and the darkest dark. Then you can design the other values in relationship to those. Or you can establish the middle value and go in both directions from there. The important thing to remember is that the roundness or flatness of a particular object will be established largely by your use of values.

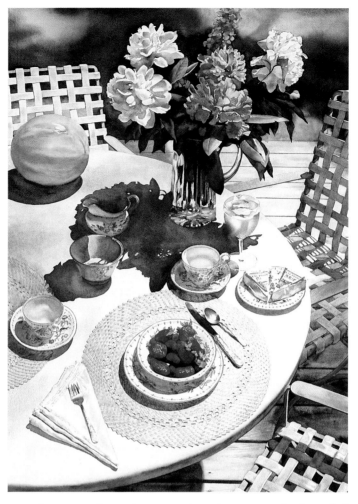

Strawberries on the Deck
William C. Wright
40" × 30"
watercolor

Look at the way Wright shows light falling on the teacups and silverware, convincing us of three-dimensional form with careful modeling.

Red Sneakers
Scott Prior
48" × 60"
oil

To create a very realistic scene in a painting, the artist must model not only the main objects, but all of the details. It's in the consistent portrayal of light and shadow on all the forms of the subject that the illusion of reality is created. Notice the care with which Prior developed the values in a detail such as the electrical outlet. By looking at this one small item, you can tell exactly where the light source is.

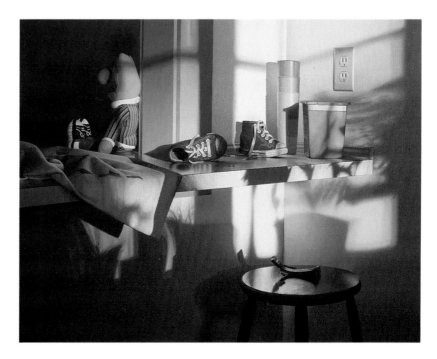

Painting a Value Scale

Every object you observe has a particular home value. That's true for colors squeezed from a paint tube as well. Yellow, for instance, is nearly white in value. Red and orange approximate the middle range of the tonal scale, whereas blue, green and purple tend to have dark home values. To become familiar with the idea of home values, let's paint a value scale consisting of five tones. Later it will be useful for comparing the values of each color in your compositions.

Exercise

Begin by drawing a horizontal series of five 2-inch squares at the top of your canvas. We are going to fill each of the squares with a progressively lighter value. Start with black and end with white (fifth square), filling in three evenly gradated values in between. Keep the paint consistently opaque, and remember to clean your brush thoroughly after every mixture, being careful to keep each tone free of any trace of a previously mixed value. Be sure each tone touches the next, because any white space between values makes accurate judging more difficult. If in doubt about the accuracy of a value, squint your eyes and compare it to the tones above and below it. Study the contrast between each value and make sure it's consistent. Does the overall effect appear to smoothly gradate from dark to light? Is the scale free of any jumpy spots or weak contrasts? If not, repaint any problem areas until the sequence looks even.

Rather than give numbers to the different gradations, think of the tones as simply white, light gray, middle gray, dark gray and black. These easily remembered names are less confusing than a system of numbers.

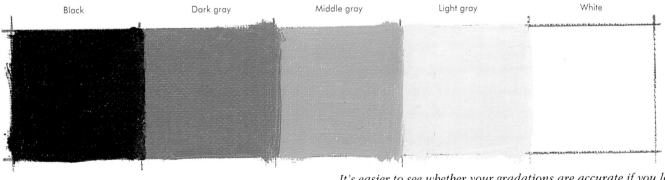

| Black | Dark gray | Middle gray | Light gray | White |

It's easier to see whether your gradations are accurate if you let each value touch the next rather than leaving strips of white canvas in between.

Using Value to Create a Center of Interest

Drop an orange jersey onto the dark green grass of a playing field, and even from a considerable distance the garment will attract attention. On the other hand, throw a worn, leather baseball mitt onto the same field, and from just a few yards away the object appears to melt into its surroundings. Subduing a secondary segment of a composition by framing it with a patch of similar values or accenting a focal point by surrounding it with contrasting tones is a device painters have used for centuries. The principle is easily understood and, once learned, can be a mainstay in your tonal repertoire.

The following exercise uses this device to help you have control over the focus, pattern and mood of your composition. Using the same five values discussed on page 45, set up a still life composed of half a dozen pieces of fruit or vegetables ranging in value from middle gray to white. As a centerpiece, choose anything from a blackened cooking pot or frying pan, to a wine jug or any other large, dark form that tonally contrasts with the lighter items. You'll also need one piece each of light-, middle- and dark-toned cloth or drapery for the different backgrounds employed. These could be random pieces of fabric, old shirts and dresses, bath towels, or even sheets of paper or cardboard.

Begin by draping the lightest of the three backdrops over the base and up the vertical wall of the empty stage on which the objects will be placed. Illu-minate the area with a strong light from either the left or right. Next, arrange the items so one light-toned and one middle-toned piece of fruit or vegetable overlap the shadow side of the larger dark-toned centerpiece. The four remaining pieces should be within close proximity but should not overlap the two that will eventually form a focal point. The aim of this lesson is to feature a different segment of the still life in each of the three sketches *without* repositioning any of the items, so take your time until the arrangement is set up according to plan.

Exercise

Divide your painting surface into three equal sections. Sketch three identical compositions of the subject before you begin painting. For your first painting sketch, paint the subject as it appears, because the strong contrast between the dark centerpiece and the light background is all that's needed to form a center of interest. For the second sketch, however, feature one light-toned and one middle-toned piece of fruit instead of the large dark pot. When these tones are set against the same light background, the task proves difficult because of the overpowering presence the pot assumes against the background. Replace the light background drape with the middle-toned fabric. The pot then recedes in importance and the fruit assumes a more dominant stance. There still remains one last hindrance, because all of the pieces of fruit assume equal importance. The way around this is to slightly darken all the values on the light side of the fruit *except the two featured pieces*. Likewise, you'll need to slightly lighten all the tones on the shadow side of the secondary items. One final adjustment: Assuming the dark side of the pot appears black in shadow, lighten all the values in that area to a half-step between black and dark gray, *leaving a soft halo of black around the two featured pieces of fruit*. This takes attention away from the overpowering mass of the pot and focuses attention on the fruit, directing the strongest value contrasts around the center of interest.

In your final sketch, focus on two *light* home-valued pieces of fruit. Replace the middle-toned background drape with the dark one. Now that both pot and background are dark, the problem changes. The various light- and middle-toned items are clearly seen, and the two featured pieces of fruit can be accented using the previously used spotlight effect. The new problem is to get the pot to still appear defined, yet keep its proper secondary position in the composition. The solution is to employ what artists call a *passage*. This means *darkening* the values beside the light side of the object and *lightening* the values beside the dark side of the form. In the case of the pot, the device not only helps define the form of the object but also gives added dimension to the area. This light-against-dark, dark-against-light principle can be used again and again in your pictures to emphasize a form and add to the illusion of space.

The white background emphasizes the dark of the pan and minimizes the lighter-home-valued pieces of fruit.

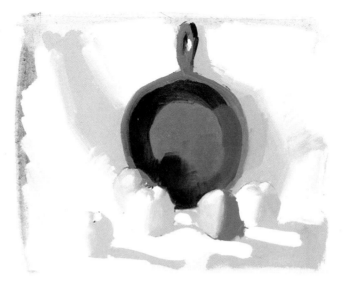

The middle-toned background subdues the importance of the pan and places emphasis on the two light-home-valued pieces of fruit.

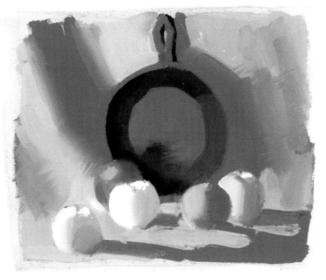

The dark background places even more emphasis on the light home values of the two apples while making the darker pieces of fruit and the pan appear to merge into the background.

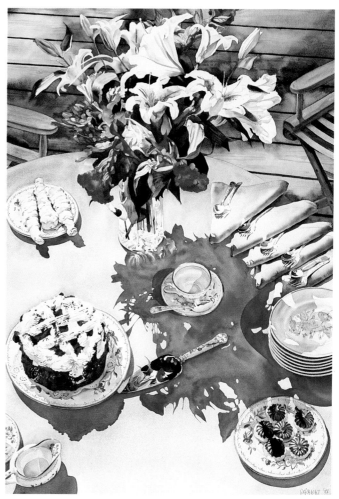

Shadows and Mood

Not only does value define form, but when used as shadow, it helps to develop mood. These four questions will have a big effect on the emotion of your painting: Are there shadows in the composition? Where do they fall? How big are they? How dark are they?

A scene with no shadows or very light shadows will tend to appear happy and peaceful. On the other hand, a scene that is mostly in shadow will tend to be mysterious. Dark shadows add even more drama and mystery. If shadows appear to be encroaching on the main figures or objects, the painting will appear ominous.

Many artists add strong cast shadows to create more interesting divisions of space in compositions. However, it's important to be aware of the emotional effect these shadows have as well.

Carnations in Winter (left)
William C. Wright
28″×21″
watercolor

Chocolate Brunch (right)
William C. Wright
39″×29″
watercolor

Both of these paintings are of still lifes in sunlight. Each one is an arrangement of colorful domestic objects on a tabletop. The main difference between the two is the value of the shadows. In Chocolate Brunch, *the shadows are comparatively dark, and those dark shapes against the very light areas of the painting cause a dramatic weight. In the other painting, most of the shadows are in the light range, and the feeling of the image is light and airy.*

EXERCISE: DARK SHADOWS

Paint or draw a simple still life. Carefully render each object, but don't include any shadows.

Repeat the still life, but this time add shadows. All the shadows should be in the light-to-medium range. Don't include any dark shadows.

Repeat the still life again, this time making all the shadows very dark.

Compare the three compositions. Notice that the painting with dark shadows is more dramatic than the others.

Sideboard
Deborah Deichler
15¼" × 30½"
pastel

Deichler uses a spotlight to create ominous-looking shadows in her paintings. Even simple objects become dramatic in her extreme patterns of dark against light.

Nice
Pat Mahony
8¼" × 9"
watercolor and gouache

Cast shadows can often seem ominous or mysterious. Here the dark window shape provides mystery, but the shadows in a soft middle value are simply interesting shapes.

DEMONSTRATION
A Dramatic Reality

What makes Deborah Deichler's paintings so powerful is that they look totally real to the eye and jar the mind. There are incongruous elements, objects that don't make sense, strange lighting—things that make the viewer pause and try to figure out the mystery.

Deichler is brilliant at capturing three-dimensional form. The items she puts together in a setup are always a bit strange, but we never question their reality. She creates bold, unusual lighting in each composition by carefully recreating the light and dark values of the image.

Some people think Deichler's work looks real because of the careful rendering of detail. She says that she actually minimizes detail in her paintings. The foundation of each painting is value and draftsmanship. After the value and shape relationships are clearly defined, she adds only enough detail and texture to convince the eye that the object is really there.

She emphasizes that value is the key. She says, "Volume will appear flat without value. Even flat paper on a flat wall can be given a sense of volume by an edge of value."

STEP 1

Deichler begins with a light charcoal sketch of all the objects' outlines. From the very beginning, she uses pastels that are as close to the final color and value as possible. She works from top to bottom because of the falling pastel dust.

The white of the teacups and rabbits represent her lightest lights, which appear even lighter because they are surrounded by dark shadowed areas. With pastel, she obtains her darkest darks by mixing strokes of black with dark reds, purples, blues or greens.

STEP 2

She moves down from the top to create the dark shadowed areas that frame the painting. She works loosely and sketchily, with much smearing.

STEP 3

For colored areas such as the green cabinet, she develops the values with gray or grayish colors first, concentrating just on where the light and shadows are falling. Once the values are in place, she goes back and refines the color.

Humidor With Easter Basket
Deborah Deichler
43" × 31"
pastel

STEP 5

Here, you can see how rigorously the artist developed all the values throughout the painting. Look especially at the range of values within the darker areas. Varying the darks makes a much more interesting painting than if the shadowed areas were all pure black.

STEP 4

Where the brightest light is falling in the painting, Deichler has carefully modeled each form. In the shadowed areas, she simply suggests the forms and details, and that suggestion is enough to complete the image.

UNDERSTANDING COLOR PRINCIPLES
The Basics and More

Color, like many other things, has a basic structure on which more complex concepts are developed. Understanding and using this basic structure will help the painter see and mix good color.

The Primary Colors

All color, no matter how complex a mixture or how subtle it appears to a viewer, originates in the three primary colors—yellow, red and blue. At equal distances from each other on the color circle, each of the primary colors can be expanded through mixing with one of the other primaries to create the secondary colors—orange, green and violet. The primary colors together with the secondary colors make up the six basic families of color. There can be no more new families of color made beyond the secondary colors. However, the six basic colors can be mixed together to make different variations of these colors. For instance, green can be mixed with more yellow to make yellow-greens, or blue can be mixed with it to come up with blue-greens. If there is enough mixing of adjacent colors, an unbroken, continuous ring of hues will be made.

Hue, or Family of Color

Most colors are not bright and intense, falling somewhere between full intensity and complete neutrality. However, every color belongs to one of the six basic color families. By determining the family to which a color belongs, you will have a dependable and helpful direction to follow for color mixing. First eliminate the color families it does not belong to. This approach is especially helpful in mixing the more neutral grays that are difficult to identify.

Although the primary colors can be mixed to obtain the secondary colors, there are limits to what the actual color pigments can mix. For instance, no single red pigment can mix into both an intense orange and an intense violet. You have to use a cadmium red light to mix the orange and an alizarin crimson or magenta to mix the violet. The yellows and blues also are limited in mixing but not as much as the reds. Cobalt blue could be considered a true blue, yet it will not mix an intense and brilliant yellow-green like viridian green and cadmium yellow pale. Since cadmium yellow light is a warmer yellow, it mixes better into an intense orange, while the cooler cadmium yellow pale mixes into the greens.

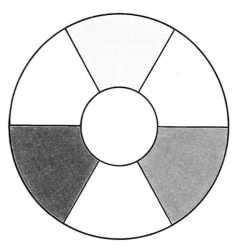

All colors originate from the primary colors—yellow, red and blue.

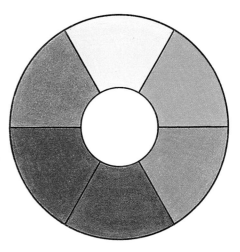

The yellow, orange, red, violet, blue and green hues or families of color are the six basic colors of the color wheel.

If adjacent hues are mixed together, an unbroken ring of hues will result.

Different colors can have the same tonal value.

Tonal Value

Every color can be placed somewhere on a dark-to-light tonal-value scale. Only the values of black and white are without color because they are too dark or too light for color to be seen. Even the lightest yellow is still darker than white, and the darkest violet is lighter than black. That is why the darker color pigments of ultramarine blue deep and alizarin crimson appear to brighten when a small amount of white is added to lighten and bring them out of their deep darkness.

Many different and opposite colors can share the same tonal value. This helps to unify a color arrangement by holding or grouping different things together. Common or close value relationships also help the painter to model using color temperature. Making a form's color slightly warmer or cooler without drastically changing its tonal value can make its surface advance or recede.

Intensity or Saturation

Since many colors in nature do not appear intense or bright, much of the color we see is somewhere between neutral gray and a pure intense hue. To mix these subtle variations, a painter must reduce the intensity or saturation of a pure hue.

A fully saturated color is at its brightest and at its greatest intensity. When you mix a completely different color with it, a less intense color results. Colors that are opposite on the color circle are ideal for this purpose because they contain none of the color being changed. If enough of an opposite is added to a fully saturated color, they will produce a neutral gray.

The intensity or saturation of a color is reduced by adding its opposite. Here, yellow was added to violet, red to green, blue to orange, etc.

Full Intensity

Reduced Intensity

Learning to See and Mix Good Color

Hue

Seeing and recognizing the correct hue or family of color is the first step toward mixing it. In this picture, the red family is used because that is the basic color of these apples. Grays blended from red are used as a background for support and balance to the stronger red in the apples. When starting a painting, always put in some of the background next to the main subject. This makes it easier to see the subject's correct color. Premix all the colors on your palette to use as base colors for blocking in this first stage. They will also provide you with beginning color mixtures for further mixing.

Value

Only by using value can you construct form and create a feeling of light. Because some edges are hard and some are soft, the round surface of the apples is clearly shown.

Some gradation of value and color is painted into the first flat colors of the background for interest and unity. The same family of red in the background grays pulls the picture's color harmony together but still gives enough contrast to enhance the red apples.

Intensity

Variation in color intensity along with warm and cool color contrast give this picture its final appearance. The way color looks in a subject always depends in part on the color of the light. With a warm light, as in this picture, an orange-red color is introduced into the lighter areas, and the shadows become darker and slightly cooler. Strong highlights help to complete the round form of the apples.

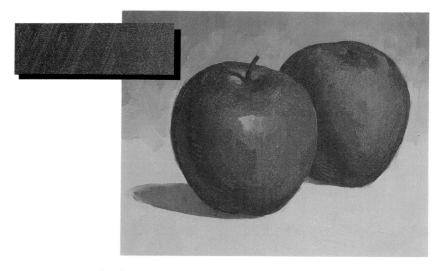

Basic Still Life Techniques

The Palette and the Color Wheel

Since there are only six basic families of color, placing your color pigments on the palette as they appear on the color wheel is an excellent way to see their relationships with each other. As long as a definite color family can be seen in a color pigment, its proper place and relationships on the circle can be found. Intensity or brightness of color in a pigment has nothing to do with its placement. For instance, terra rosa can share the same orange-red place on the color circle as cadmium red light. In the same way, the very cool ivory black shares a place with cobalt blue. Any color pigment belonging to the blue family will always give some kind of green when mixed with yellow family colors.

Placing your colors on the palette in this manner helps give you control in color mixing. If the warmer yellow and red pigments are placed together on one side of the palette and the cooler green and blue pigments on the other side, then the color pigments are in the basic relative position they are on the color circle.

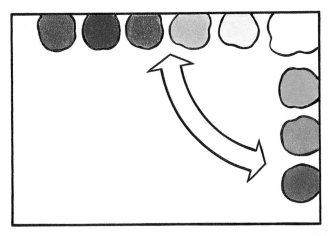

Lay your colors out on the palette just as they are positioned on the color wheel for easier mixing control. Keep the warmer yellows and reds on top and the cooler blues and greens on the side. Place your white in the corner.

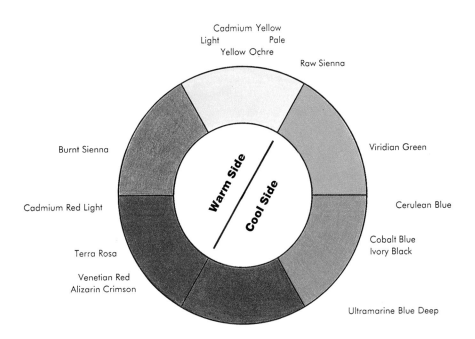

All color pigment can be placed somewhere on the color wheel. Several color pigments can share the same place because they are basically of the same color family.

By having color pigments on your palette that are both warm and cool and knowing their relative position to each other on the color wheel, much more control is possible in color mixing. If you want a bright and intense color, you must use bright and intense pigments. If you want a grayer version of the same wheel, add a little pigment from the opposite side of the color wheel. When choosing pigments to mix together, first determine their position on the color wheel.

Rich Color With a Limited Palette

The Palette

Joni Falk normally sets out a fairly full palette. She mixes a variety of grays to be used for warm and cool variations. A variety of purples is also prepared, as are several greens, all keyed to colors she sees in her subject. A small pan holds Winsor & Newton's Liquin. It is her favorite medium because it gets tacky quickly, which allows her to lay color on color and blend tones without lifting the base layer.

While Falk usually uses fresh flowers in her arrangements, she has selected this arrangement of dried and silk flowers for its ability to last the extended time of the demo.

STEP 1

Initial Lay-In of Color. *To start with, Falk coats her canvas with an olive green/burnt sienna wash, thinned with Turpenoid. While the paint is still wet, she dips her brush in the solvent and lifts out areas where lighter flower petals will be. As she wipes out the flower petals, she also begins to rough in some of the shadowed areas, using the same colors. The composition begins to emerge.*

This serves as the original thumbnail sketch. This monochromatic "sketch" enables Falk to concentrate on values and composition without concern for color at this early stage.

Compositionally, the two large poppies are the center of interest. There will be whites for a crisp look, establishing the lightest values, and little highlights of yellow, the complement of violet, for color contrast and sparkle.

STEP 2

Blossoming Out. *Plunging right in, Falk tones both poppies dark violet, the paint layer kept as thin as possible to keep it workable. Then, coming back over each petal, she blends in lighter shades of her premixed violet. A touch of green is added at the center of each blossom. Gradually, she builds up the pattern of lights and darks she sees in each petal, brushing in a variety of violets—some warmer, some cooler—to maintain visual interest.*

In finishing the painting, Falk has adjusted the tablecloth to a cooler hue and highlighted the bowl by making it warmer. Warm, pink reflected light glows in the shadows on the right half of the bowl, preventing it from disappearing into the foilage or the background.

Fallen petals have been placed on the cloth to break up its smooth expanse. They stop the eye, moving the viewer's attention to the highlights of the bowl, then upward, as the artist intends.

Color intensity has been increased on some of the irises, and a few more groups of yellow flowers have been added, properly subdued with yellow ochre to keep them out of the highlighted value range and to round out the arrangement. A few bright yellow-green leaves at the far right and left catch the light, coming forward against the dark background shadows.

STEP 3

Defining the Value Range. *Mixing indigo with Indian yellow, Falk begins scrubbing in dark leaf masses around the poppies, establishing the darkest values that will appear in the painting.*

With these darks in place, she moistens her brush with Turpenoid and begins lifting out some of the daisy petals that will later be brushed in with white, just suggesting them at this point to see how she likes the effect.

Using white, with just a touch of ochre, Falk begins brushing in the foreground daisies, noting that these will be a warmer white than the bowl.

Falk has learned to limit the greatest contrast to about a third of the surface, allowing the rest of the painting to lead up to it. That one-third can be a horizontal or vertical pattern that moves through the painting.

STEP 4

Establishing the Color Dynamic. *The flower bowl, which will be the largest mass and the lightest value in the painting, is now brushed in with shades of white and warm gray. The underpainting shows through at this stage.*

The right side of the bowl becomes a bit cooler, as its edge becomes lost in the dark tone that she now adds as the shadow. Yellow-green is added and blended with the shadow tone, and the background is extended upward and around.

Dark red-violet is now scrubbed in to form the two flower masses at top left and top right center, and blue-violet is added for the four smaller blossoms.

STEP 5

Defining Flowers. *Working across the painting, Falk begins to define individual blossoms, extending the composition upward and out. The cluster of violets at right center is roughed in, then the irises at top right and center. Falk prefers to work on shadow areas first, coming back with the lights. This way she can easily manipulate the full range of values.*

The bright light striking the picture is the highlight on the bowl, moving upward through the poppies, curving right, then left to the background at top. By softening values at left and right, this vertical emphasis will become even more important as the painting progresses.

Purplish-grayed whites are used to lay in the flowers at right, and more shadow-toned petals are added to the daisies at center. Highlight-white brushstrokes bring some of these petals forward to create the brightly lit daisy at left.

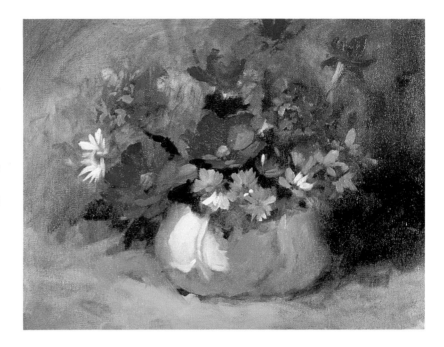

STEP 6

Bringing It Up. *With basic flower shapes established, Falk adds dark green values between the masses, working all over the canvas. Scrubbing in leaves and greenery, she establishes a rhythm of dark masses that travel horizontally across the canvas.*

Continuing outward, she adds the lighter-tone flower at top left. Then, standing back from the painting, she decides that the poppy petal values need rethinking. The artist reevaluates and adjusts the values in each area in relation to those just developed around it.

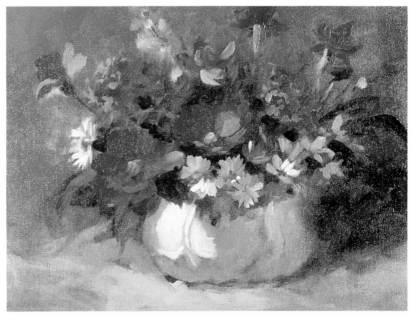

STEP 7

Dealing With the Background. *Before detailing any more of the foliage around the perimeter of the arrangement, Falk turns her attention to the background.*

A soft, grayed, dark violet is first scrubbed in at top left. Blended with a midrange grayish green it becomes lighter as it widens out in both directions. Falk scrubs her background right into the already painted flower masses, causing some to disappear entirely. (They'll be recovered later.)

The area that will become the iris at top left is lifted out of the background with Turpenoid on a brush, then brushed in with dark purple values. Lighter shades of the violet are added and blended over these.

With the background brushed in, Falk rebuilds the smaller flowers around the perimeter. Then she turns her attention to the varied greens of the leaves and to the highlighted and shadowed daisy petals.

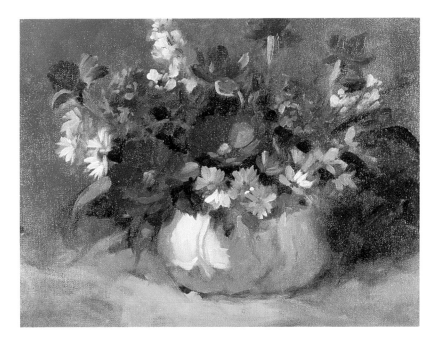

STEP 8

Highlights Add Dimension and Sparkle. *Further adjustments are made in the values and color of all the purple blossoms. Before beginning on the tiny yellow flowers, Falk brushes soft, feathery strokes in a range of light greens into the darkest green shadow areas, suggesting a network of fine stems and leaves.*

Because the poppies and iris are so large and bold, the tiny wildflowers, added gradually, create a nice contrast in both size and color.

As she paints the yellow flowers, Falk continually goes back to other areas to spot in white, pale violet and yellow-green highlights, adding bright sparkle across the surface.

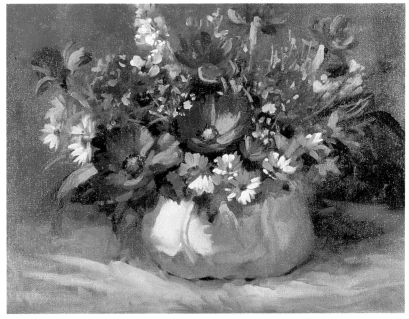

STEP 9

Heading for the Finish. *More time was spent on the background, intensifying and warming it at top left and darkening much of the rest of it. Some of the flower shapes have been developed, too, especially those that show against the background.*

The painting is predominantly cool colored, so for a warmer feeling, Falk warmed many of the whites and the background.

The process of highlighting and adding contrast to the surface with small points of white, yellow and violet has also been continued and is beginning to create a bright outer "shell" of highlights that sparkle against the inner, shaded core values.

Falk begins to detail the bowl, being careful that it doesn't distract from the floral arrangement.

The cloth is also more fully modeled now—brightest where it is struck by reflected light from the white bowl, disappearing against the background in shadowed areas.

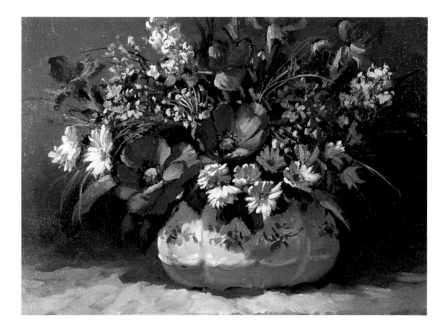

The Color Dynamic for *Lavender and Blue*
The artist has played her monochromatic scheme against yellow-based complementaries. Greens and blues soften the color contrasts.

Basic Still Life Techniques

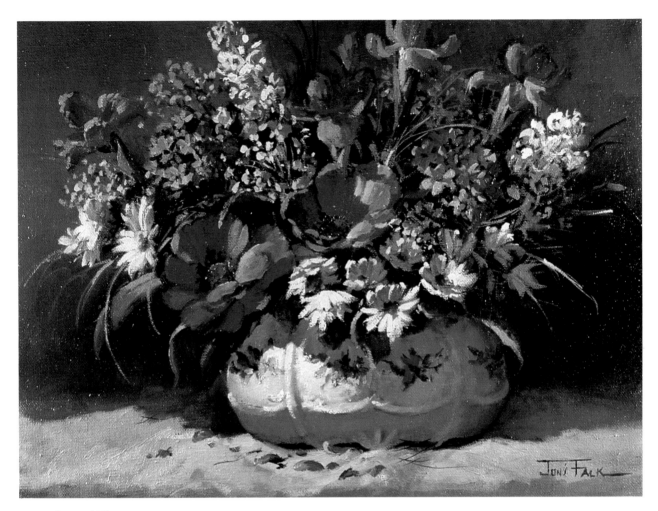

Lavender and Blue
Joni Falk
12" × 16"
oil on canvas

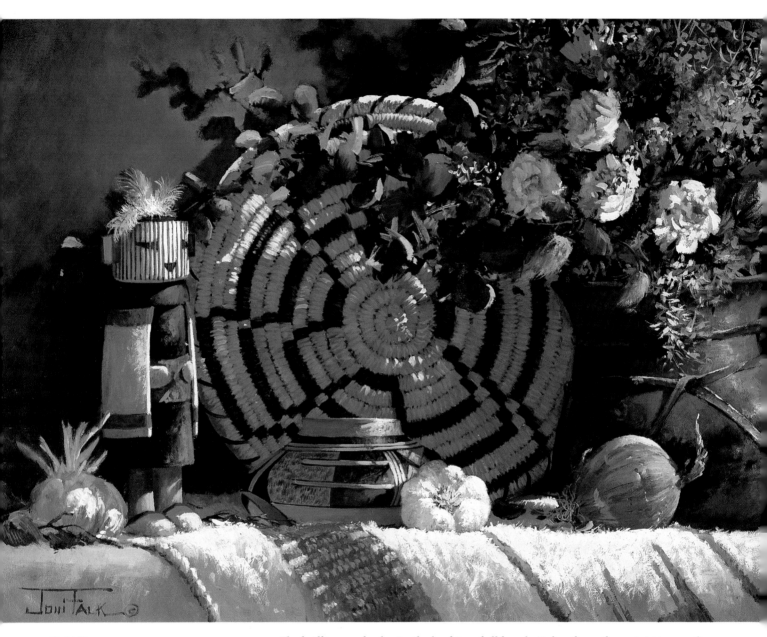

Hopi Treasures
Joni Falk
12" × 16"
oil on canvas

The brilliance of color in the kachina doll breaks it free from the restrictive confines of the limited palette employed everywhere else in the painting, bringing this composition to life.

The Taramara pot at right, with its wonderful patina, is contrasted against the yellow of the onion as a secondary center of interest.

Textural contrasts are also employed to advantage in Hopi Treasures, *as textures of blanket, flowers, basket and kachina are expertly played against the smoothness of the onion and pot.*

Petals and Clay
Joni Falk
5" × 7"
oil on canvas

The simplicity, directness and power of this painting belie its diminutive size, proving that miniature paintings need be no less effective than their larger counterparts. Strong contrasts in size, shape, value, texture and color are the keys. Notice particularly how the smoothness of both background and pot contrasts with the rough-edged, brightly illuminated; high-value, high-chroma flowers. There can be no doubt about the center of interest in this painting.

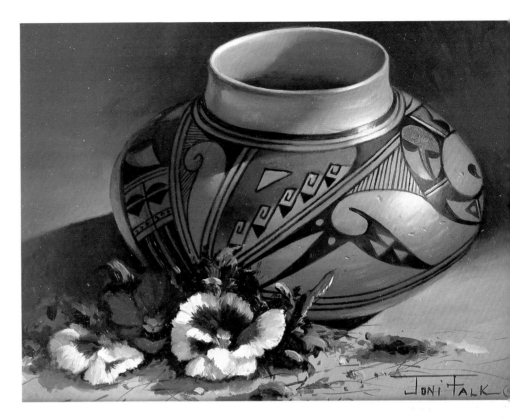

Summer Radiance
Joni Falk
36" × 36"
Joni Falk
oil on canvas

This arrangement of Gerber daisies appears to include every color in the rainbow. In reality, it is an analogous color composition in intense warm tones, with violet and blue color contrasts. A strong vertical is formed by the fallen daisy and the folds of the cloth at bottom, moving upward to the pink daisy at top. The viewer's eye, entering at the yellow daisy on the left, follows the increasingly red blossoms to the same pink daisy and to the repeated pattern of the daisies at right. White and violet blossoms further involve the eye in a circular movement through the painting. The brass bowl and dark bronze background echo the golden daisy, confirming the warm character of the composition.

DEMONSTRATION
Building Color With Lines

Many artists use lines for the initial drawing of their paintings, but Bill James makes line part of the painting process itself. James does not rub to create form or depth, but rather he uses a series of color strokes to form the elements being drawn.

This technique of laying down and leaving individual strokes of color is vi-

tal to James's practice of bouncing warm colors against cool colors. Rather than blending strokes to achieve grayed colors, he allows the colors to vibrate against each other. From a distance, the eye blends the separate strokes, but up close the painting dances with vitality.

In this demonstration, you can see

James's imaginative use of color. Even when outlining objects, he uses strong bright colors to add sparkle to the finished piece. For example, the violet and pink first used to outline the large vase are still visible in the finished painting. In James's work, no stroke of color is a ''throwaway.'' Every single line helps build the final image.

STEP 1
James draws in the main elements using colors complementary to the color each element will finally be rendered in.

STEP 2
He works in the background to get a better idea of how the subject matter is progressing. Before doing the final rendering on the vases, he draws the flowered pattern and also indicates the shadow and color separations on the glasses.

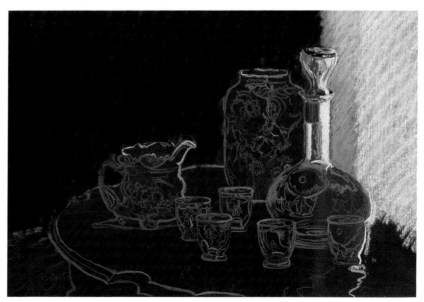

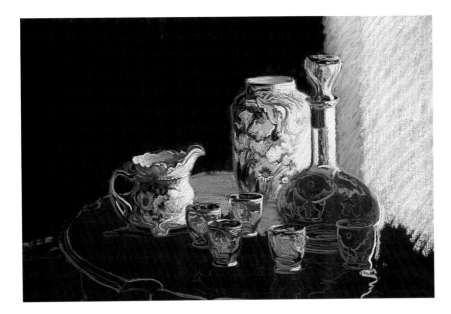

STEP 3

James starts working in the color on the vases. Notice that because the colors of the vases themselves are on the warm side, he did the initial drawing in complementary blue and green colors. He also started working on the color of the table.

STEP 4

He continues rendering the table and starts adding color to the glasses. The rug in the lower left corner is worked in, and the table is completed. Final touches are added to all the elements in the painting. More complementary color is added to make the subject matter really jump out at you.

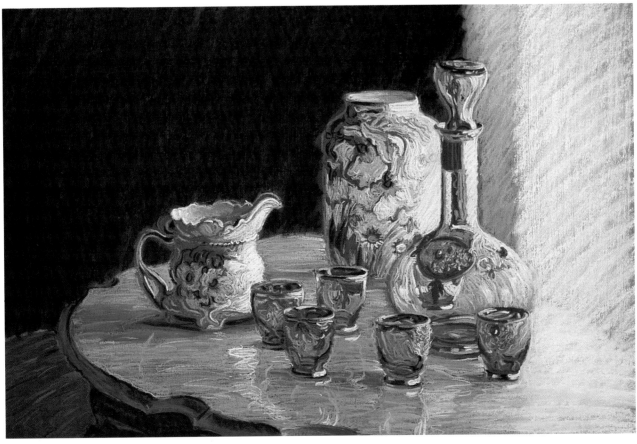

Still Life in Blue and Gold
Bill James
18" × 27"
pastel

SPECIAL TECHNIQUES

For Some Difficult Subjects

This chapter covers only a few of the many techniques you will be using in still-life painting—but some of the ones most often asked about. We will study techniques for painting both transparent and reflective surfaces in oil and watercolor, which can add a touch of mystery or dazzling sunshine to a composition. We will also look at good, solid techniques for handling oils with brush and knife. Once these skills have been mastered, you'll be well on your way to creating satisfying compositions.

STEP 1

Study the vase and look for color in the water. Work on a dry surface and paint in the lightest values, letting the colors flood together. Let them dry.

STEP 2

Look for darker shapes within the vase. Use the darker values and colors you see and paint them freely. Here, Jan Kunz painted around the stems because their sunstruck side is lighter than the background. If the stems had been darker, she would not have avoided them.

Transparent Surfaces in Watercolor

Glass vases and jars may appear difficult to paint, but they can be surprisingly easy. The trick is to think of the shapes you see within the vase or jar as just that: a collection of shapes that you can paint one at a time.

The cut crystal vase on the next page appears more complicated than this plain glass vase, but the painting method is the same.

STEP 3

Now it's time to add the stems and leaves within the vase. You can see that Kunz has tried to be fairly careful with these shapes.

STEP 4

Mix a light-value puddle of cobalt blue. Use a clean brush and a light touch to paint over the entire vase, adding more color on the shadow side. Let it dry.

Finally, lift highlights with clean water and a stiff brush. Be sure the highlights follow the contour of the vase.

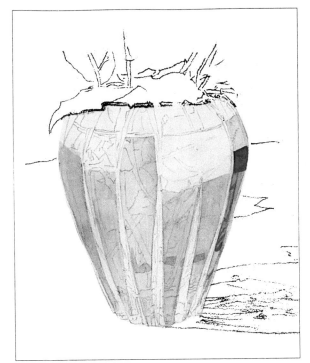

STEP 1

Working with a fully loaded brush, begin on the left side of the vase with a pale passage of Winsor blue. Warm the color with ultramarine blue as you approach the other side.

STEP 2

This vase is divided into faceted surfaces, providing natural stopping places. Reproduce color and value using blues with rose madder.

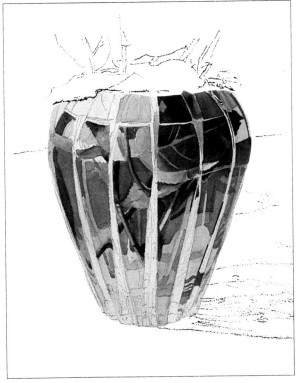

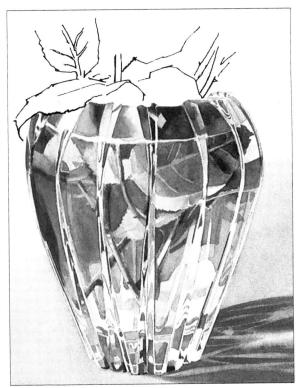

STEP 3

Begin to suggest leaf and stem shapes, now and then making them extend from one area to the next.

STEP 4

Add the dark accents along the edges of the faceted surfaces. Light streaking through the glass—created by lifting pigments from the previously painted shadow— creates soft-edged designs.

Reflective Surfaces in Watercolor

Successful painting is largely dependent on training your eye to *see*. You need to forget what you know and paint the shapes you see before you. The shapes in reflective surfaces may not make sense, but they define the surface of the object you are painting. You can do it, and it's fun!

STEP 1

Carefully draw the cup and include any shapes you may see. This teacup is cream colored. The vertical side facing the light is toward yellow, but the horizontal surface of the saucer is more toward green. Let these first washes dry.

STEP 2

The shadow shapes are four values darker than the sunny side. They may possess strange shapes, but be as accurate as you can. Make them appear to follow the contour of the surface. Notice that the interior of the cup receives reflected light from the opposite side.

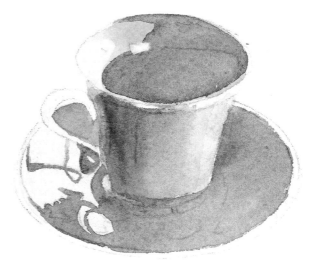

STEP 3

Now for the fun part. Paint the extra squiggles you see within the large shadow shapes. Add the gold trim using burnt sienna, new gamboge and alizarin crimson.

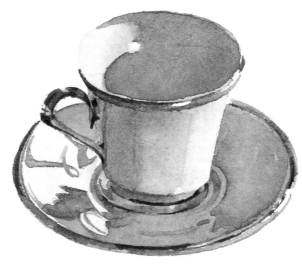

Basic Still Life Techniques

Reflective and Transparent Objects in Oil

There are no set rules for painting reflective or transparent objects except to keep squinting and looking. Anything reflective or transparent collects what is around it, as the examples on this page and on pages 70 and 71 show.

Detail of *Red and White* by Patricia Moran. *Every time you paint there is a new set of problems to solve. This little glass vase with its opaque pinky-red top would have been painted in a completely different way in a different setting. Transparent objects take on the tones of their surroundings and therefore look different each time you paint them.*

Detail of *Chrysanthemums in Oriental Vase* by Patricia Moran. *Same vase with a completely different set of tonal values. Glass seems so hard to paint because there is often a very complicated pattern of light and dark, some of which is on the surface as reflected light, and some of which is around and behind the object, visible because of the transparency of glass. The only answer is to simplify by squinting until only the most important tones can be seen, and then paint what you see, not what you know.*

The pictures on this page are details of paintings by artist, Patricia Moran, as seen in her book, *Painting the Beauty of Flowers With Oils*.

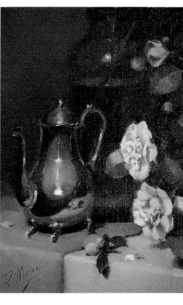

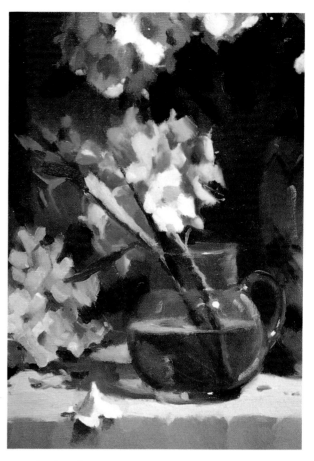

Detail. *Reflective objects "collect" their surroundings by reflecting them. If you tried to define the silver pot better, with harder edges or a more "silvery" color, you would actually be losing the likeness rather than getting closer.*

Detail. *This glass jug would look completely different with the tulips or a different setting. You wouldn't know it was the same jug. You're not painting jugs; you're painting tonal patterns.*

Detail. *In contrast to the silver coffee pot above, this copper teapot has aged beautifully and isn't highly polished, so it isn't picking up a lot of its surroundings.*

Detail. *This polished copper pot is picking up some of the yellow-rose color. Remember that reflected light is not as bright as direct light. It's like moonlight compared to sunlight. Be sure the reflections belong to the object and don't just sit on it.*

STEP 1

This step-by-step is a detail of a demonstration by Pat Moran. First, the soft, nondecisive tones have been placed.

STEP 2

Using oil medium and establishing the darkest darks. The flowers are one step ahead of the vase. Notice that the glass vase and the bowl are progressing at the same rate.

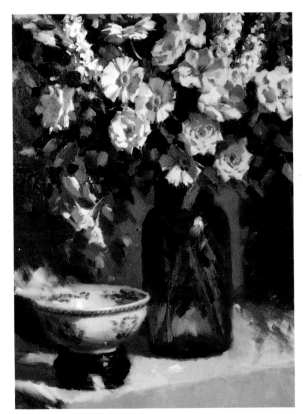

STEP 3

A little more work on both the bowl and the vase, more measurement, reassessment and adjustment. That is, more rubbing out and putting in again! Ellipses can be a problem.

STEP 4

Completed. If the vase looks like glass and the bowl looks like china, it's because the artist painted what was observed—tone, edges and proportion.

Surfaces for Pastel Painting

These three still lifes by Richard Pionk show how the type of surface can affect the finished image. In *Bittersweet and Apples* on Canson paper, the color has an overall smoothness to it, and the values tend to stay in the middle tones.

Working on a gessoed board for *Reflection*, Pionk was able to underpaint to get greater value contrast—notice the stronger shadow area. Also, the board gives greater texture to the pastel strokes, creating a more interesting surface texture.

In *Grapes and Apple*, he was able to get the greatest value contrast on sandpaper; the luminous grapes seem to bounce off the bottle. Because sandpaper grabs the pastel and holds many layers of pigment, it enables the artist to build up intense color that rivals the finest oil paintings.

Bittersweet and Apples (top)
Richard Pionk
19″ × 24″
pastel and Canson paper

Reflection (middle)
Richard Pionk
16″ × 20″
pastel and gessoed board

Grapes and Apples (bottom)
Richard Pionk
9″ × 11″
pastel and sandpaper

Using the Brush With Oils

How well you know your brushes will determine how well you paint. Below is a sample of brushstrokes by artist Joyce Pike. For the scrubbing stroke, load a brush with paint thinned to the best consistency for your purpose. To cover larger areas, such as a background, use a no. 10 or 12, flat- or long-bristle brush; each gives a slightly different finish. You will need to practice to determine what you want and where. Contrary to common belief, the best coverage occurs when the thin part of the brush is touching the canvas. One example shows a controlled drip, where a large amount of turpentine was mixed with the paint and allowed to pattern as it dripped down the canvas. This effect is interesting for distant areas and for some backgrounds. Leaves are often painted using a loaded no. 6 brush. Paint leaves with a direct straight stroke as you see in the green area of the sample. For most leaves, don't make a rendered shape, but use a straight stroke. A more realistic leaf shape can be formed with a scrubbed stroke. Stems and leaves are best painted with a rigger.

Better Brushwork Demonstration

In this step-by-step by Joyce Pike, you will see how to paint a single object, in this case an antique pitcher. It's very hard to describe a brushstroke, so follow the steps to see how many brushstrokes add up to a finished painting. As you prepare to paint, you will need to follow a pattern; putting the cart before the horse can result in sometimes uncorrectable problems. Following a simple procedure can save time and prevent many problems.

STEP 1

First, scrub in a light tone with turpentine-thinned oil paint. The brushstrokes are purposely random at this point to provide a tone and a neutral foundation on which to build. With a small brush, draw in the outline of the pitcher carefully, starting with the plumb line and being especially careful to draw the ellipses correctly.

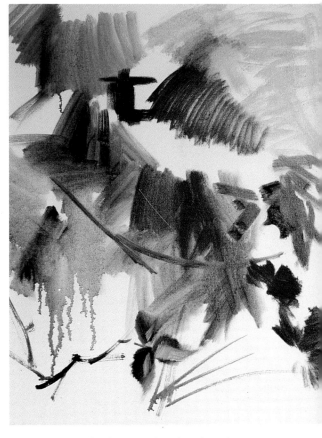

STEP 2

Softly hit the surface of the canvas with the brush bristles, adding darks and lights to the pitcher.

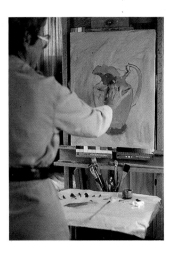

Here is a sample of Joyce Pike's brushstrokes.

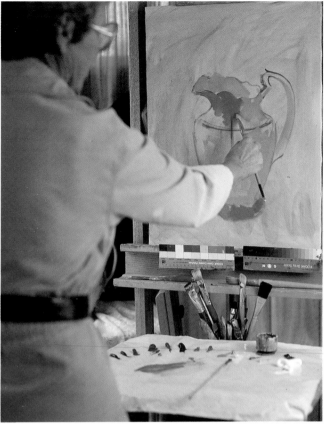

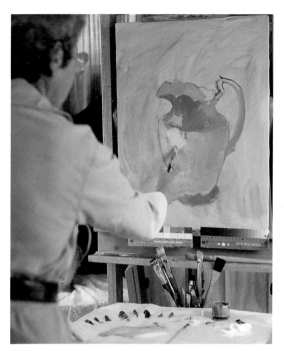

STEP 4

Using the same type of direct brushstroke, apply the highlight with fairly thick paint.

STEP 3

Holding the brush like a stick, make a scrubbing stroke, keeping the hand and arm loose. Always keep your wrist flexible.

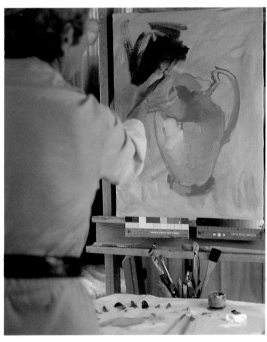

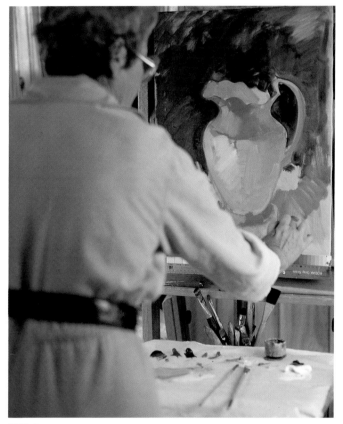

STEP 5

Load the brush with a dark mixture to apply the background with loose and easy strokes. Think about creating lost and found edges as this dark meets the light of the pitcher.

STEP 6

The shadow cast by the pitcher onto the white cloth is placed using a scrubbing stroke to use the full amount of paint in the brush.

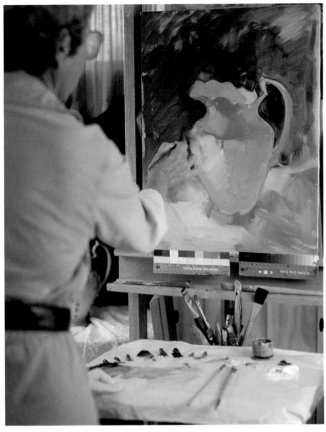

STEP 7

Here you can see how to soften an edge to create lost and found brushstrokes.

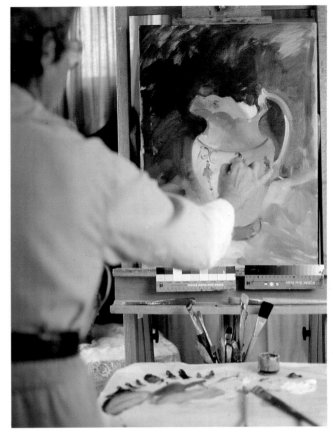

STEP 8

Add the decorative trim using a thin application of Grumbacher Red with a no. 2 long bristle brush. Suggest only a few of the rosettes. If some of your lines are a little weak, don't worry. The eye can fill in softer areas.

STEP 9

Practice subjects are just that. Don't try to make a finished painting—that would defeat the purpose of practicing. Here you can examine the loose, direct brushstrokes.

Using the Knife With Oils

Knife work can be added to any painting. It's a good way to make a strong statement. The knife can be used, often better than a brush, to apply clean paint over a spot of bad color. If you have painted a gray background and wish to break up negative space or just add more color, the knife can frequently do a more interesting job than the brush. For this, load your knife, place it directly on the wet canvas, and pull down or push up, moving the paint off the knife onto the canvas. If edges are a little sharp, soften them by laying the knife flat and scrubbing lightly. This blends the edges into the background. It's best to work wet on wet, but there are times when adding knife strokes over a dry surface will give a beaded effect. Do this with one stroke—if too many strokes are placed in this manner, the effect will become too busy. You may find it necessary to soften some edges when knife work is added wet on dry as well. If so, take a brush and lightly soften where the knife and the brushwork on the background come together. Knife and brush can work together as a team. Learn to handle both and determine for yourself where each is best used.

In this study, the loosely painted petals were placed in with both brush and knife. The initial lay-in was done with the brush, and a few overlaid strokes with the knife created some finished petals.

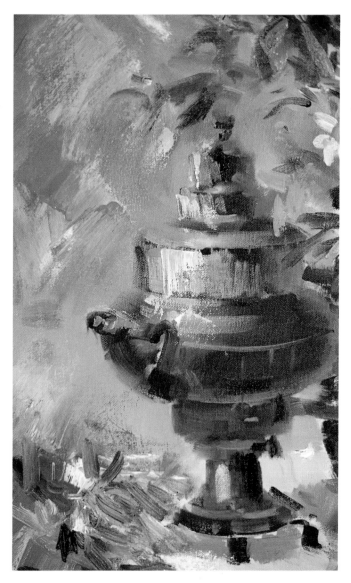

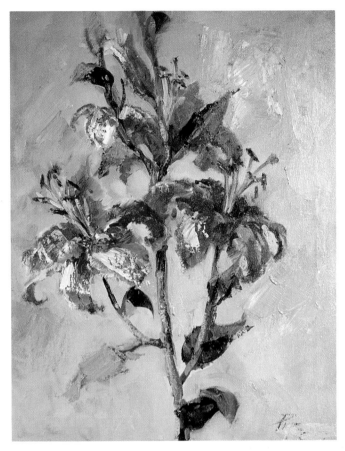

Practice study of blossoms done with the painting knife.

Practice using the knife for flowers with only a few blossoms. First, paint the darker center areas of the flowers with your brush. For this lily, Pike used alizarin crimson. With a knife loaded with Weber Floral Pink plus a touch of white, she used a single, direct knife stroke to create each petal. The brush was also used to suggest stems and leaves. A few finishing touches of the leaf pattern were added with a knife.

Most of the background was brushed on. The overlay stroke with touches of cerulean blue was applied directly with a knife and preserved by not overmixing.

DEMONSTRATIONS IN OIL

DEMONSTRATION

Beginning With a Neutral Tone

For the first demonstration, begin the painting in a neutral tone. Many tonal realist painters begin this way, and it's a good way to understand that you are painting a light effect on objects, *not* the objects themselves. Alter the light source and a different pattern of lights and darks will appear.

To paint the block-in with this method, squint your eyes and look at the subject. Then with one neutral midtone, establish the shadow areas, leaving the light areas untouched on the white primed canvas. *The shadow will explain the object.* If you mix with your eyes fully open, the local color will take precedence over the tone. Remember, the correct tones are your primary consideration in establishing the truthfulness of a subject. Think tone.

Pastel Shades
Pat Moran
28" × 36"
oil

On page 79, you see the steps that led up to this full-color painting. Color and detail were added, but the tonal values have stayed consistent with the neutral-toned block-in.

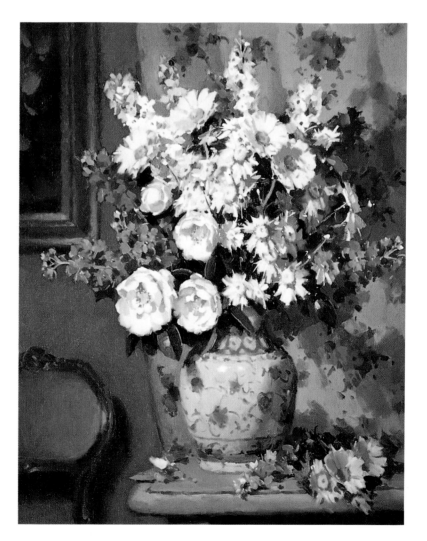

STEP 1

Here, one neutral midtone has been applied for the shadow area, and a vase of flowers is already appearing. You can see how the shadows explain the object.

STEP 2

The darkest darks are added, again in a neutral tone, and there's no mistaking what's beginning to take shape. This is a tonal picture. Now these tones have to become color.

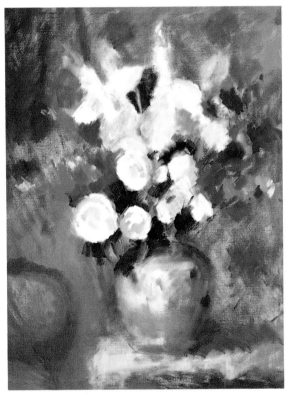

STEP 3

By observing from this standpoint and keeping the eyes half-closed while mixing the colors, you will be able to see the tone take precedence over the local color. As you add some local color, take care that the tonal value of the color matches the tonal value that you see with your eyes half-closed.

STEP 4

Here, stand oil is added to the turps, and the darkest darks are established. You can see that there is a dark green and a dark purple; different colors, the same tone.

Fruit With Luster

This painting is busy with all sorts of fruit and flowers. Color also obviously commands attention. What do you do when your subject is bright and colorful? How much can you safely say without becoming gaudy? In this setup, the table full of cut and whole fruit is alive with rich color. With so much color in the fruit, a strong color was needed in the flowers. The one luster is ruby glass under an overlay of white porcelain. When the design was etched in the glass, the red showed through, making the luster a gaily decorated piece of art glass.

In the finished painting, unity is achieved by tying together the values and colors. The darks in the fruit tie together with the darks in the foliage. The color is strongest in the fruit, making it delicious to look at. A few flowers merge with the background, allowing the ones around the focal point to come forward. The white vase and luster merge slightly with the background. They are softened, yet still visible. Touches of the fruit colors are seen in the flowers and background, and vice versa. The brushstroke is loose and direct everywhere except where details are strong. Compositions do not always need to be strong and glaring; subtle compositions can be even more exciting.

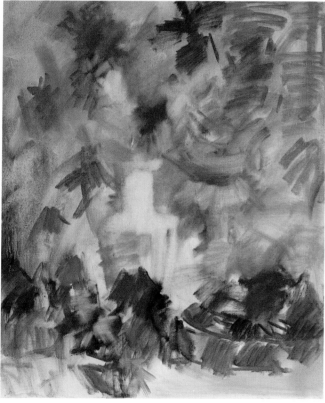

STEP 1
Because the artist intended to use bright colors, she didn't apply a wash or a toning but went directly to areas of thinly applied pure color. This shows how the colors will relate in the finished painting.

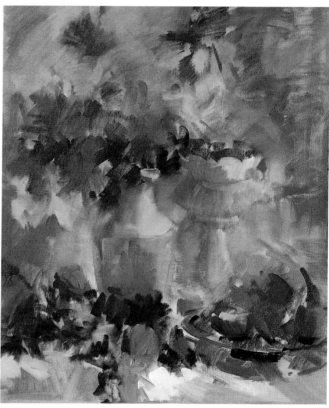

STEP 2
The composition is established by securing all the dark patterns. The easiest way to see where you are going is to work out the color and composition first, before you consider detail or finishing.

Photograph of the setup.

Fruit With Luster
Joyce Pike
24" × 20"
oil

Each object is carefully placed so detail work can be started. Keep stepping back to take a good look at your composition as you paint to make sure you don't go too far. This painting is alive with color, warm dominating cool. Brushstrokes maintain the busy look the artist wanted. Note the focal point: The strongest dark-and-light contrast is where the dark foliage is near the light flowers.

DEMONSTRATION
Iris and Hat

As the artist selected objects to go with a beautiful hybrid iris, she first considered color. The blue-violet background drape and the blue Spanish shawl on the table are major elements in this painting. The pink ribbon on the hat and pink tones in the background tie in with the light pink-violet iris. The three yellow irises in the bouquet are a complement, repeated in the gray-yellow hat. The jeweled box and pearls add animation by giving the eye a place to go.

STEP 1

Toning and Sketching. *A wash of dominant and complementary colors is applied using paint thinned with turpentine and allowed to drip. Tints of color are suggested where the objects may be placed. Allow the canvas to dry about fifteen minutes before starting to sketch, then sketch the placement of each major object in a simple but accurate drawing.*

STEP 2

Lay In. *Each object is laid in according to shape and color without detail. A loose, direct brushstroke keeps things from looking finished too quickly. This approach will allow you to be more selective with detail and also will allow you to make sure all colors and values are working.*

STEP 3

Selecting the Focal Point and Relating Objects. *Your eye will go to where the darkest dark and lightest light come to-gether. In a floral still life, this should be within the floral arrangement itself. If all other objects are closer in value, this focal point can be seen first. Here, the light iris is a focal point. The composition is planned so the eye moves down to the hat, then to the pearls, completing the trip through the painting. The drapes and subtle objects continue the balance of color or value.*

Iris and Hat
Joyce Pike
40" × 30"
oil

The color and value balances are set. At this stage, as long as you don't make major changes, you can finish as much or as little as you wish. Step back frequently and take a good look. It's a mistake to start having such a good time that you forget to check how you are doing.

Pretty Bouquet

This setup was used for a workshop lesson. A selection of several flowers makes up a pretty bouquet: mums, roses, daisies and a few stalks of red-violet gladiolus, one in the bouquet and two on the table for color. The dark vase brings out the light of the small porcelain pitcher. In the photograph, you see a pink ribbon draped over the gladiolus. The artist chose not to place it in the finished painting.

Photograph of the setup.

STEP 1

Toning the Canvas. *Toning the canvas first allows you to see relative values more clearly. Using ultramarine blue thinned with turpentine draws in the correct placement of each object. Use an oil wash of red-violet grayed with sap green. Here, the dominant hue is violet with only a touch of yellow complement, seen in the centers of the daisies and used to gray all hues throughout the painting.*

STEP 2

Blocking In. *This part of the painting process will let you see what the painting will look like when completed. The only thing missing is the detail. Each object is blocked in using correct color and value both in shadow and light, keeping shadows cool and lights warm. Always block in flowers with stronger and darker color to increase contrast.*

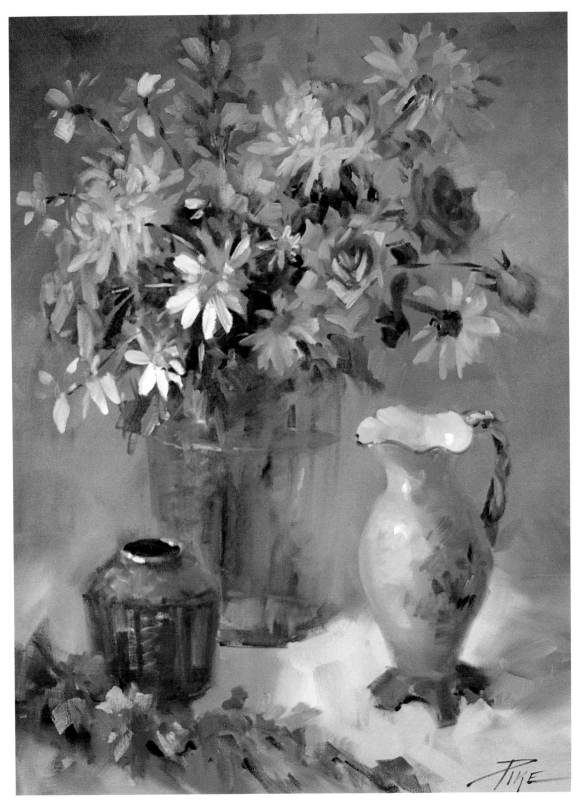

Pretty Bouquet
Joyce Pike
24" × 18"
oil

Now detail can be added without changing established values or colors. Work first on the white daisies against the dark green foliage. They are the focal point. Develop each remaining flower relative to the daisies. Some flowers are only suggested. The vase holding the bouquet is almost lost to make the small, blue-violet pot and porcelain pitcher come forward.

Look for a comfortable corner of your yard where setups can be placed and models posed. Work with what you have or add props. In the painting on these pages, some concrete steps, several rose bushes and a retaining wall make a cozy area where chairs, tables or even a blanket can be placed on the ground and can become exciting to paint. Try using large pots of petunias. Here, an orange tree in a large whiskey barrel with rusty bands adds a lot of character. You can do a lot to arrange things yourself. The grass and sunlight will make it clear that you are painting outdoors.

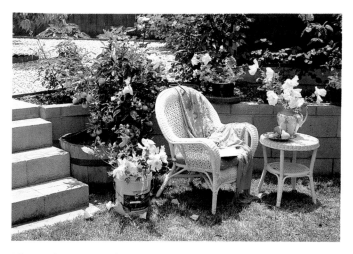

This is the corner of Joyce Pike's yard where she sets up a lot of outdoor paintings. There are many elements to help make interesting compositions.

The contrast is strong to show the strong bright lights hitting the white objects in front of the dark foliage. The strong cast shadow makes the composition complete. The blue shawl in the chair breaks up all the white. The entire painting will be cool blue-green with beautiful warm lights that touch the whites. On a hot summer day, use warm lights. When there are clouds, or on an overcast day, your lights will be filtered, so make them cool.

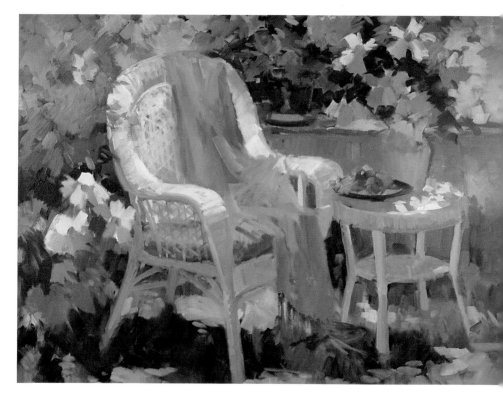

Setting in the Yard
Joyce Pike
30" × 40"
oil

Here, a few more poppies were added in the background, and detail was added to the ones in the pitcher on the wicker table. The embroidered flowers were added to the shawl. With a bit more refining, the wicker and fruit were brought to a finish. Once everything was complete, a few final touches of light were added on the chair, table and matilija poppies, and the yellow centers were completed. When viewers look at a painting like this, they should want to be a part of it, to mentally feel comfortable sitting in the chair in the sunlight.

Chapter Eight
DEMONSTRATIONS IN WATERCOLOR

DEMONSTRATION
Basket of Fruit

A basket of fruit is a perfect subject for learning how to paint still lifes. The beautiful forms of the fruit are enhanced by their rich color and provide an ideal challenge for the water-colorist.

STEP 1

1. Underpaint the basket with raw si-enna. Next, use a mixture of alizarin crimson and cobalt blue to underpaint the top edge of the basket that reflects the sky. Use alizarin crimson to do the left side of the basket that's turned from the light. Let it dry. Suggest the form of the basket weave by moistening the area with water and adding darker value to the individual vertical ridges.

2. Underpaint the yellow fruit with new gamboge and the red fruit with alizarin crimson. Remember to keep vertical sur-faces warm and horizontal surfaces, or areas turned form the light, a cooler hue.

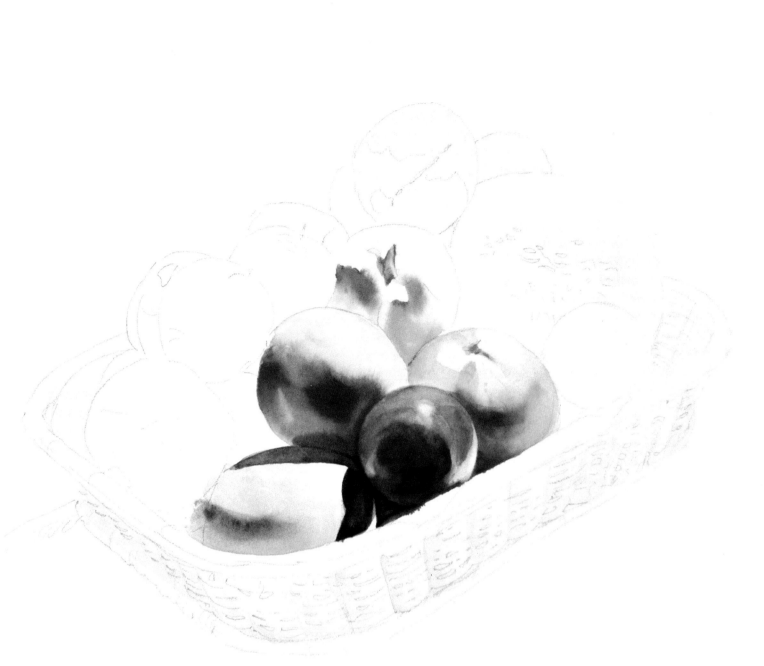

STEP 2

Paint each piece of fruit one at a time, exploring the possibilities for capturing color and light as you go. You might want to put white artist's tape along the rim of the basket to protect it. Let's start with the orange in the front, using new gamboge and cadmium red light to make a rich orange color. Add alizarin crimson to this mixture to slightly cool the top. The shadow area is alizarin crimson with a bit of new gamboge at the base. To create the illusion of sunlight, remember that vertical surfaces are hotter than horizontal ones. Now paint the apple, plum and peach, using mixtures of alizarin crimson, cadmium red, new gamboge and raw sienna. The area in shadows should be 40 percent darker than the sunny side. You can add reflected light to the shadow side that echoes the color to be found in the adjacent fruit. Remember, cast shadows usually have no reflected light and are 40 + percent darker than the areas upon which they are cast.

STEP 3

Work in this manner going from fruit to fruit. First, paint the local color and let it dry thoroughly. Then add the shadow side including the reflected light color. Be careful of the edges where the sun and shadow meet on the rounded surface, and keep them soft. After the shadow side is dry, add the cast shadows. The crevice darks between the fruit are a combination of burnt umber and alizarin crimson.

STEP 4

Now finish the basket. First, paint the inside of the basket with some detail suggesting an open weave by using a dark mixture of burnt sienna and alizarin crimson. Treat the body of the basket as a solid form, painting the areas turned away from the light with alizarin crimson and burnt sienna. Use a darker value of these colors on the shadow side

with hints of new gamboge to suggest reflected light. Reflected light isn't very obvious until you get something dark next to it.

Paint the detail on the basket loosely. Begin with a very dark value mixture of alizarin crimson and burnt umber under the vertical straws. While the pigment is still wet, wash out your brush

and pat out enough water to leave it moist but not really wet. Dip your brush into the wet pigment on the basket and draw the paint out horizontally to suggest the weaving.

It is not necessary to paint every detail. Paint just enough to suggest the texture of the basket.

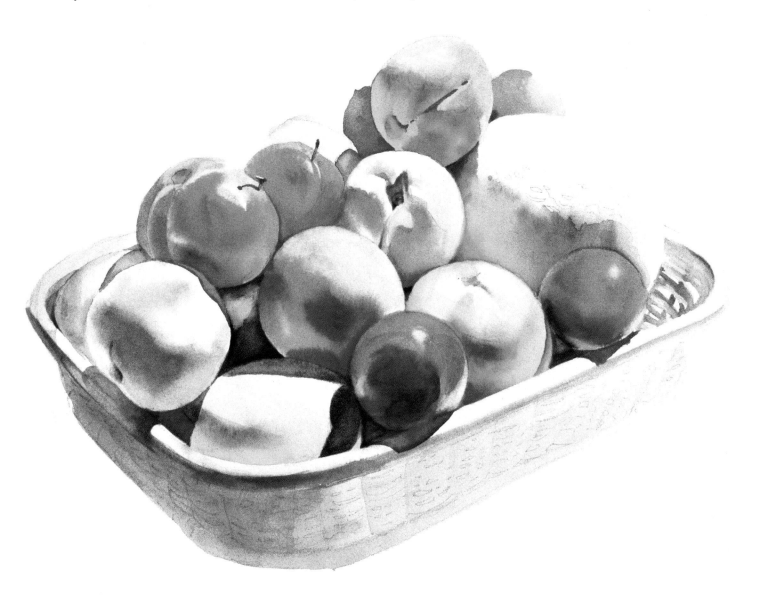

DEMONSTRATION
Casting Shadows

William Wright thinks of his paintings as abstract designs of dark and light. He uses strong backlighting to create long shadows that become as much a part of the composition as the objects themselves.

When Wright chooses objects for a setup, he looks for pieces that have a range of forms and textures. He selects them with an eye toward how light acts on them—how it passes through glass, reflects off silver or bounces light and color into deep shadows. In some of his paintings, he will even crop off the flower arrangement and make the painting just about the shadows.

Wright uses traditional watercolor techniques, working from light to dark. He always starts by painting the white objects first, mixing several grays predominantly from cerulean blue with touches of vermilion and raw sienna. As the painting progresses, he layers stronger and darker colors over each other to model form, saving the blacks for last.

Family Setup
William C. Wright
39" × 29"
watercolor

STEP 1
A very precise pencil drawing lays out all the value shapes and most of the details.

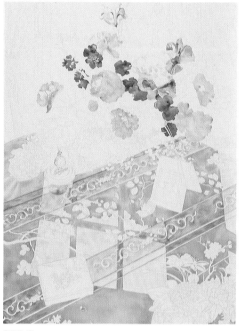

STEP 2
Now some of the key colors are painted, using lighter values in the areas where sunlight falls. The light and shadow areas are defined from the very beginning.

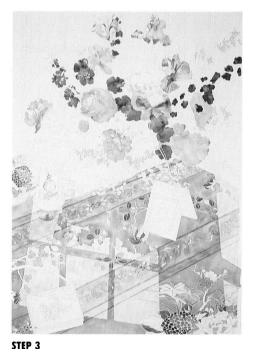

STEP 3
More colors are added, and those that are already there are intensified.

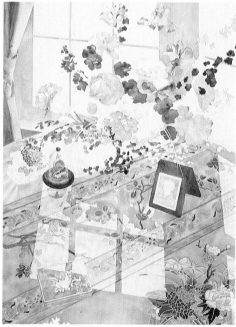

STEP 4
Try working over a whole painting at once, keeping the entire painting moving along at the same pace.

STEP 5

In the last step, add the darkest darks. From isolated bits of color, the painting becomes a cohesive composition with an intriguing pattern of light and cast shadows falling from the window.

Designing With Black

Kendahl Jan Jubb specializes in intricate, decorative images built of numerous textured shapes. She works on balancing the textures so the composition will hang together and not break apart into individual patterns. Values are crucial. She says that if the values are off, the painting will pull itself apart.

In developing her composition, she starts with the focal point. She puts in the pivotal shape and then develops the patterns that lead away from or to that form, using the arrangement of textures to provide movement.

Jubb is one of the few painters who is unafraid of black. Although she does treat the powerful dark value with respect, she relies on it heavily to provide a weighty contrast to her intricate patterns. She sees the negative space as an integral part of her compositions, and by using black she is able to give the negative space more importance.

Jubb sees value as drama and uses a lot of contrast. She uses black because of the dramatic value it has. Black makes other colors more brilliant and gives the negative space more depth and more weight.

STEP 1
Jubb begins with a careful drawing of all of the shapes that will go into the painting, including even the tiny shapes that will be the pattern in the flowers. She starts painting by completing all of the pink petals.

STEP 2
Working color by color, she adds all of the blue, most of the yellow and green, and some of the red.

EXERCISE: NEGATIVE SPACE

Arrange three or four objects into a simple still life. Draw the outlines of each of the objects and fill all of the space outside the objects with black. Do not draw anything inside the objects.

When the negative space and the objects are divided into black and white, you can clearly see how the objects fit into the format. Are the objects balanced in the composition? If they are not balanced, do they need to be moved, or could you add another object somewhere else in the composition to balance them?

STEP 3

Now with all of the colors placed in the subject, she begins to add black to the negative space. The flowers have a light airy feel with white around them. This will change as she fills in the negative space.

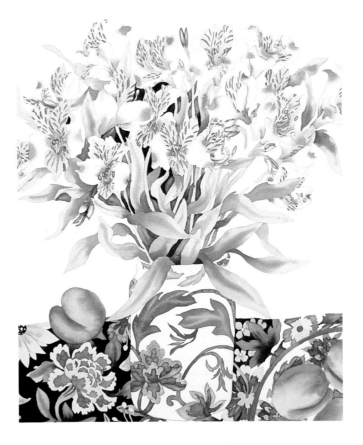

July Arrangement With Peaches
Kendahl Jan Jubb
25" × 22"
watercolor

STEP 4

Colors get more intense and the flowers look more dramatic as they are surrounded by black. By comparing Step 3 to this final image, you can see how much more powerful the composition is with black rather than white in the background. An interesting compositional element is the repeated shape of the single peach and the group of peaches. Repeating shapes or patterns, especially in a design with many shapes or textures, adds harmony to the tonal structure.

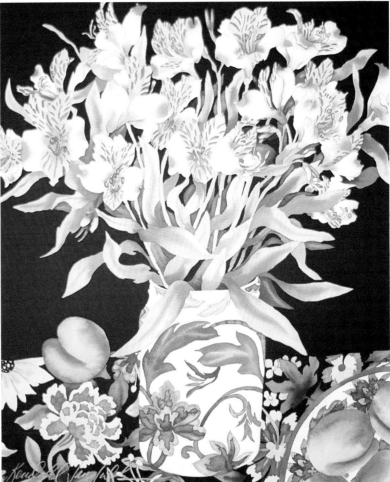

DEMONSTRATION
Daisies: Painting Reflective Surfaces

This demonstration provides an opportunity for you to paint several reflective surfaces along with flowers.

To paint any reflective surface, you may find it best to simply turn off the logical voice in the left side of your brain and just draw and paint what you see.

Set up a stage to arrange a setting for the flowers and backdrop. Your palette should include Winsor blue, cobalt blue, ultramarine blue, Winsor green, alizarin crimson, rose madder genuine, Winsor red, raw sienna and new gamboge.

STEP 1

Begin with the background. Work wet-into-wet, using various blues to create a pattern of color. Leave several white areas for the daisies, but darken the outer corners of the paper to keep the eye within the page.

STEP 2

As soon as the surface is dry, begin painting the daisies. Darken the color around some petals, letting them appear to emerge from the background.

Next, develop the fold in the background drapery. Wet the area and then add color, letting your brushstrokes follow the direction of the fold.

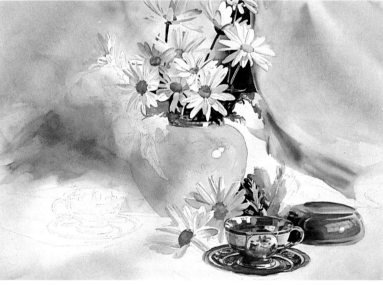

STEP 3

Underpaint the lightest value of blue on the vase and lid. Add darker shapes as they appear. To paint any reflective surface, think only of the shapes you see and reproduce them as carefully as possible. Use raw sienna, new gamboge, burnt sienna and rose madder to suggest the gold color on the cups.

STEP 4

Begin with the large vase. Paint blue-green on the right side and add a cooler blue toward the center. Use a fully loaded brush and keep a wet edge as you work across the surface. Paint around the circular highlight and the rectangular reflection. Make sure the brushstrokes follow the contour of the vase. Add darker color as you approach the shadow side.

The cups require a careful look. Examine the color and the shapes you see. Take them one shape at a time and they become manageable.

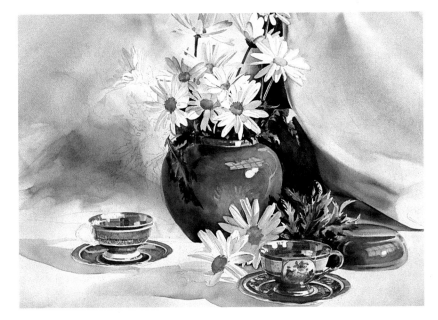

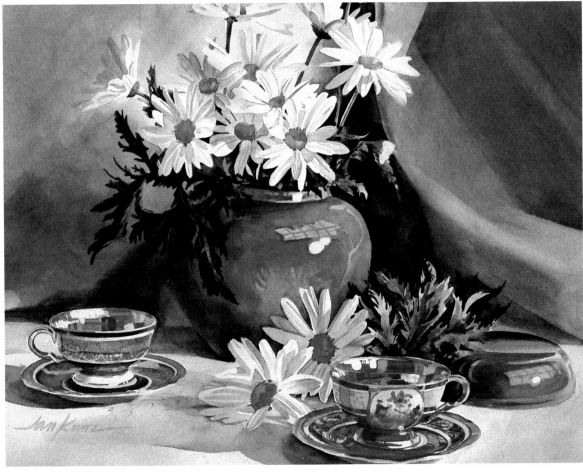

STEP 5

Rewet the background area left of the vase. Use bold brushstrokes of color across the background and into the vase itself. Let the colors merge and be lost in one another. Now for the final appraisal. If the background drape is demanding too much attention, make it less important with a glaze of blue and rose madder. To set the drape back farther still, add leaves to intersect (and break the thrust) of the fold.

DEMONSTRATIONS IN PASTEL

DEMONSTRATION
Interesting Light in the Studio

Richard Pionk is a New York artist, but he prefers to work exclusively in his studio, where he sets up and paints beautiful still lifes. Using the traditional method of setting up the subject and working from life, Pionk has maximum control of the choice of objects, placement and lighting.

Pionk chose his studio because of the north window, which provides a source of unchanging light. The lower part of the window is blocked off to give the light a downward direction as if it were coming from a skylight.

He is especially interested in the effects of light. In chiaroscuro painting, the eye follows the light, going from one section to another, and the shadows structure the painting. Pionk lets the light come in from the left to the focal point. The background is dark, and the light on objects gradually gets brighter as it moves to the right.

Pionk's interest in light is one of the reasons his paintings have a classical look. Another is his method of working from value to color. Working on a variety of surfaces, he begins each

painting with a charcoal drawing to place shapes and values, and then goes on to blocking in shapes of color.

He builds up his colors with strokes of French pastels, which he prefers for their softness and brilliance of color. In between workings of pastel, he sprays lightly with fixative, holding the can about twelve inches from the surface. He warns that too much spray can darken the pastel. Occasionally, he deliberately darkens an area by masking it off and spraying it. His thinking is, the darker the area, the more drama.

STEP 1

Start with a triangle and a fast gesture drawing with medium vine charcoal, developing objects slightly off center. This pastel is painted on sandpaper.

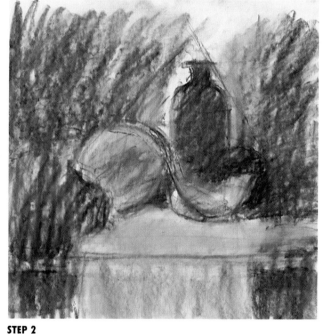

STEP 2

Block in and correct the drawing with charcoal, wiping outlines and smoothing areas with your fingers. Concentrate on the larger shapes, giving no thought to detail here.

STEP 3

Now start with hard pastel, blocking in the basic colors with corrections as you see the need for them. Pionk often draws his strokes from left to right to reinforce the direction of the light.

STEP 4

Continue to fill in the large shapes with hard pastel, using the side of the pastel and light pressure on the pastel stick, working from dark to medium to light.

STEP 5

Begin to pull out more objects by basic shape and additional color, sharpening up some edges for more clarity. In the finished painting, some edges will be hard and others soft, depending on location and lighting.

Melon and Grapes
Richard Pionk
15" × 15"
pastel

Give the surface a light spray of fixative, and move to soft pastels, giving only the necessary detail. Constantly have the thought of focal point in mind (the large melon piece). The dark grapes and melon slice act as a frame to pull the eye to the lighter, larger melon. The background is given a rich balance of shape and color. The single grapes are given added detail because of their closeness. A final light spray of fixative is applied.

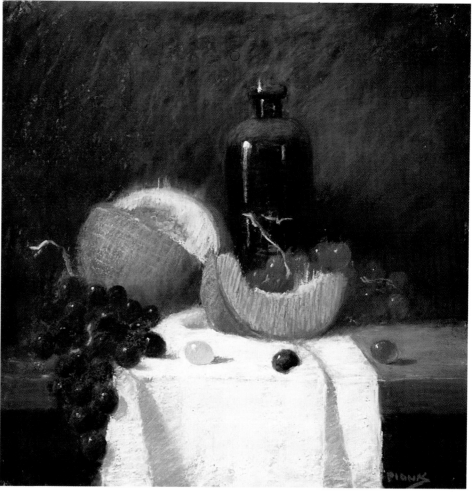

Basic Still Life Techniques

Detail. *In these details, you can see how Pionk merely suggests some shapes and carefully renders others. Those that are closer and in more light will be more precise. For softer edges, he either draws rough strokes of pastel or blends the stroke slightly with a finger.*

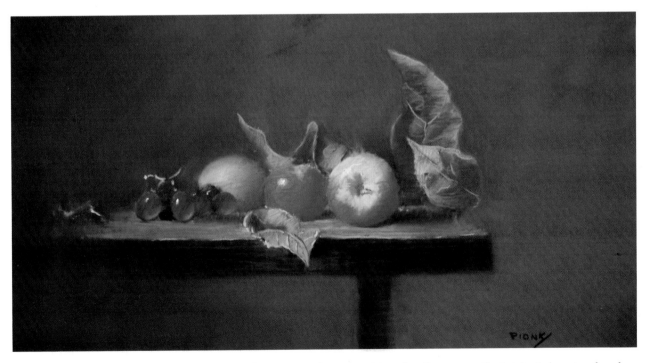

*Apples on Table
Richard Pionk
9" × 15"
pastel*

This is a simple composition that focuses on the intrinsic beauty of each piece of fruit. There are no tricks or gimmicks in Pionk's work, only deft craftsmanship combined with great patience and concentration.

Rendering Fine Detail

A passion for detail is the key to Jane Lund's virtuoso pastels. Her still lifes and figures go beyond realism in their attention to detail. Lund works up to a year on each painting, adding one tiny stroke at a time.

The various layers of color are built up slowly, beginning with Rembrandt soft pastels, then blended in with hard NuPastels. Quite a bit of time is spent sharpening the pastels with a craft knife in order to achieve the fine detail. Lund does not use fixative, so the pastel retains its intrinsic softness. Careful inspection of the surface of many of her paintings will reveal the worlds within worlds that she sees in each object.

Lund likes to work with the subject before her so she can constantly compare the painted image: Is each section expressive of the subject? Do all sections balance with each other? It is not enough to paint every single detail, but all of these details must work together for a unified painting.

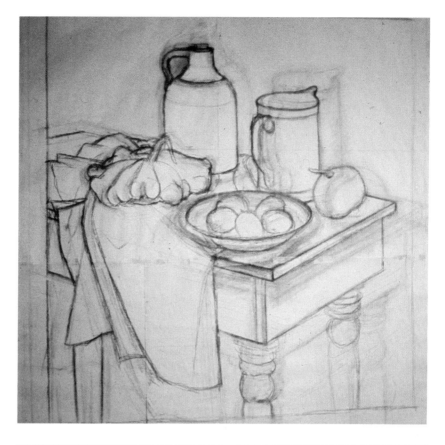

STEP 1

Lund begins a painting with a series of small sketches, one of which is enlarged onto newsprint paper (top). The composition and the scale of the painting is determined. She then transfers this drawing onto Canson paper using a light cobalt blue pastel. She refines the drawing with the light cobalt and a kneaded eraser. Lund feels that the light blue lines are easier to see as the painting progresses.

STEP 2

Lund paints with the painting upright (bottom), one section at a time, usually working from top to bottom to avoid the dustfall and from left to right to have a place for the mahlstick that supports her drawing hand.

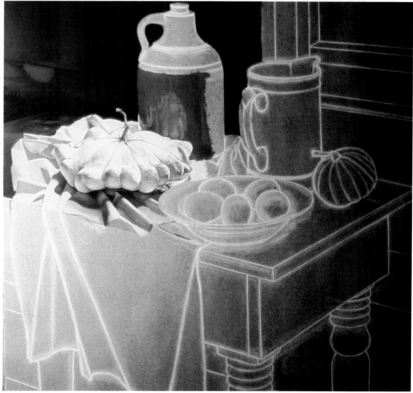

The mahl stick she uses to support her hand is made from a wooden dowel with a rubber cane tip attached to the end.

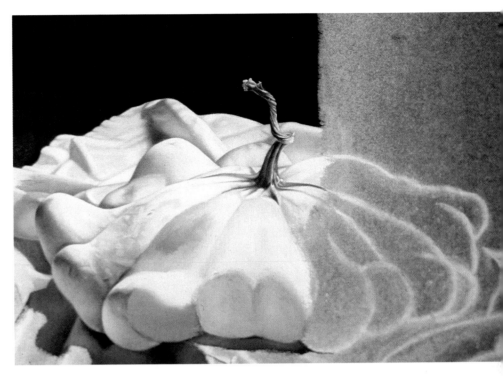

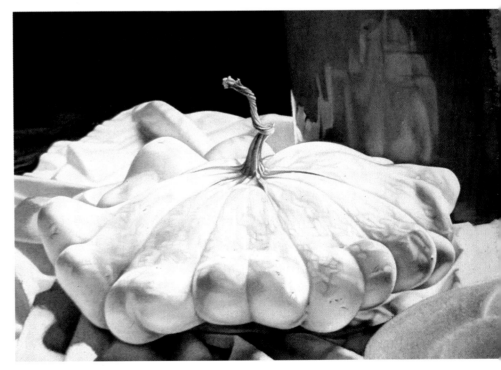

These close-ups demonstrate the rendering of an object. In the early stages, Lund tries to put in all the visual information she can see. This usually creates too intense an image, so she softens it with a "glaze" of tiny strokes that blend the details into a more unified appearance.

STEP 3

After completing the squash and jug, she starts the eggs and pitcher. She wanted to paint the squash and eggs early in the painting so they would not spoil before she was able to complete them.

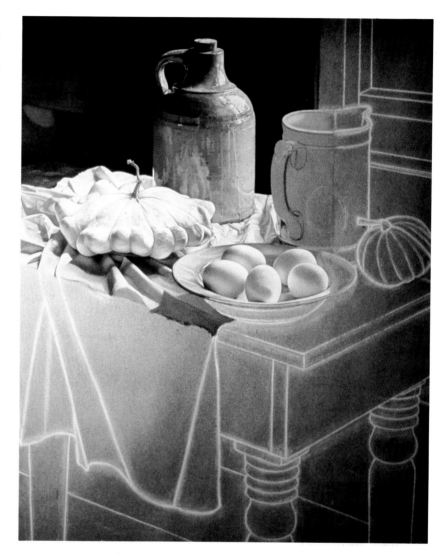

This view of Lund's worktable shows some of the tools she uses. The craft knife is used for sharpening pastels like those in the foreground. She changes knife blades often and also uses the paper border of her painting for fine tuning the points of chalk. The odd-shaped device in the center of the table is a car battery filler bulb, which she uses to blow away excess pastel dust.

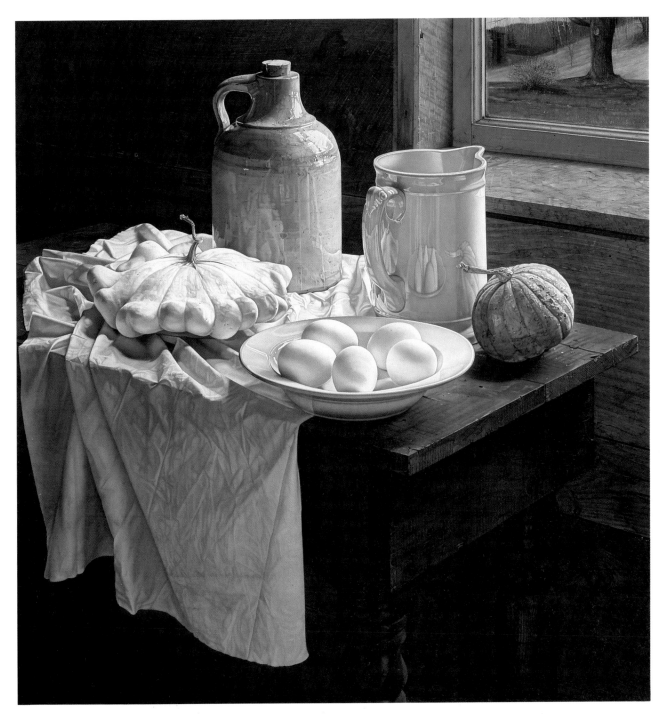

White Still Life
Jane Lund
30½" × 29¼"
pastel

STEP 4
Lund continues to add one section at a time until she has completed the entire composition. The final painting is unified, despite the piecemeal approach, because of the sustained concentration on details throughout the painting process.

Working From a Black-and-White Photo

As we discussed earlier, tonal values, the relative lightness or darkness of a tone or color, acts as the skeletal structure upon which a painting is built. Just as there are many shades of gray, from white to black, every color's shade has an equivalent gray value, from the very lightest yellow to the darkest purple close to black.

It is very easy to see and interpret tonal values in black and white; that is why simple black-and-white photographs are an excellent tool for an artist to use when studying values. In addition, photographs without color force painters to explore their creativity. Rather than locking the artist into a specific approach to a subject, black-and-white photographs offer an opportunity to investigate techniques, change light patterns, crop the scene without wasting precious painting time discovering problem areas, reverse day and night, and explore the atmosphere and emotions of a scene.

No two artists will ever interpret a black-and-white photo in precisely the same way—proof of the range of creative effort that simple photos can release. On the following pages, you will see how four skilled artists interpret the same source photo in a variety of ways. Comparing their techniques and results will expand your own inventiveness. But first let's look at how black-and-white value studies translate to color.

Establishing Values

Anything receiving light has a value. Not only does an object have local or intrinsic color, it also has a degree of lightness or darkness of that color.

The range and pattern of a picture's values are usually best determined in the thumbnail or color/value sketches that many artists make before working on a pastel. It's a simple way to assign value to the larger masses and then rearrange or manipulate those values. There are also subtle value tones within light and shadow. Knowing how dark to go in the lights, and how light to go in the darks is an important part of the versatile vocabulary of pastel.

Translating Black-and-White to Color

Without some kind of planning for tonal values, the pastelist often spends much time correcting and redoing the painting. Planning values can help achieve a balanced pattern of lights and darks that can be interpreted into color. It's helpful to work out a black-and-white thumbnail in approximately five to seven values. This provides a format for working out color decisions. You can then match color values to each value in your black-and-white thumbnail.

Black-and-white photo reference for this section.

The Artists' Interpretations

Because of the preponderance of darks and the crowded number of objects, most of the artists whose work is shown in this section felt that rearrangement and selection of objects was in order. Jill Bush created two versions of the same scene. One, a mysterious, shadowy rendition, while the other shows a more tactile close-up of some objects.

Tim Gaydos rearranged all the objects, using a complementary color scheme, creating texture, and flooding the scene with sunlight. Foster Caddell, with a major rearrangement of objects, created an intimate table scene with a subdued palette of beautiful low-key color. Anita Wolff created a tactile, glowing finish by using multiple layers, each sprayed with fixative.

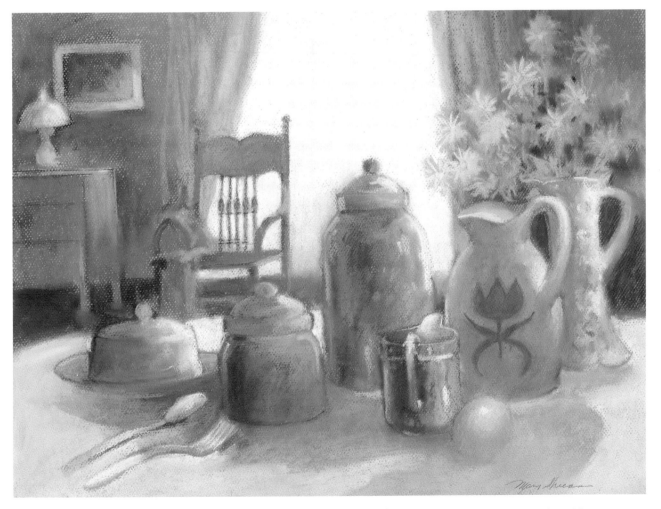

Tea Time
Mary Sheean
15" × 18¾"
pastel on paper

Sheean moved the window and chair farther back from the table, creating a much deeper space than shown in the photograph.

DEMONSTRATION

Enhance the Mood With Contrasting Values

Working on oversized, dark gray Canson Mi-Teintes pastel paper with Rembrandt, Sennelier and Grumbacher soft pastels, Tim Gaydos moved the objects in the setup to obtain a strong abstract pattern. He chose warm, subdued colors to evoke the feeling of nostalgia, quiet, and the filtered light of the photograph. He rearranged the crowded composition to eliminate objects and introduced new elements into the pastel. The windows were designed as the only source of light, since he seeks to create strong light-and-shadow contrasts in his work.

For framing, Gaydos suggests the following: a brown wooden frame with a 3″ white linen liner, or alternately, a natural wooden frame with a 3½″ warm gray outer mat and a ³⁄₁₆″ ivory inner mat.

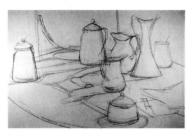

STEP 1
After moving objects and completing thumbnail value sketches, Gaydos placed the drawing on the gray Canson paper with charcoal. This is basically a map of color areas.

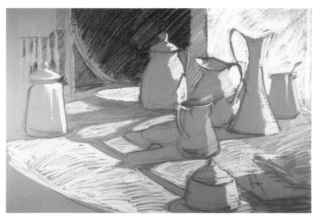

STEP 2
Next, he laid in darks and lights to create a pattern and decided to make the lower right corner dark to make the light pattern more interesting. He postponed making color decisions.

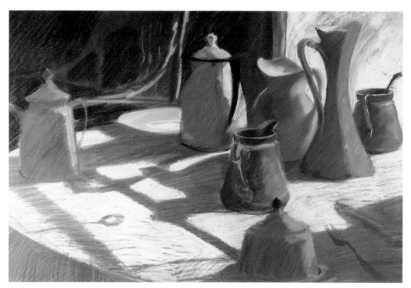

STEP 3
Here, Gaydos extended the painting to the right for better balance and reversed the high chair back to the original position to promote rhythm. He decided on a warm color scheme and added reds and pinks to give contrast to the focal point.

Basic Still Life Techniques

STEP 4

He continued changing and refining shapes and colors. The colors in the curtain are light cobalt blue, raw umber and a very light yellow. All the vessels received more color in the light and shadow sides. The brass was rendered in Prussian blue, ochres, burnt umber, English red and olive green.

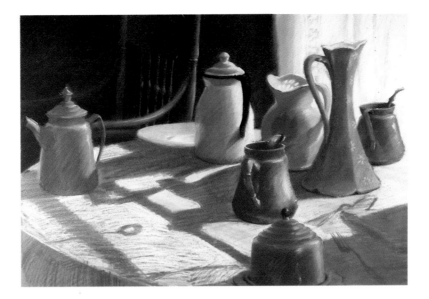

STEP 5

Gaydos felt the vessels in front did not have interesting enough shapes to hold such an important place in the composition. He substituted a jug and teapot and added dried grasses and flowers to give some life and variation to the collection of vessels. He eliminated the shadows of window sashes because they run in the same direction as the stripes on the tablecloth.

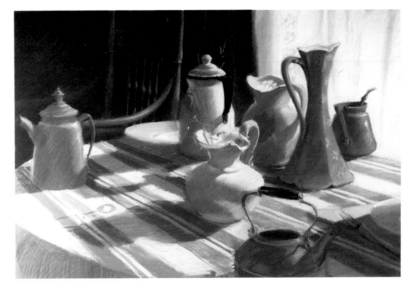

Timeless Room, Precious Objects
Tim Gaydos
25" × 34"
pastel

STEP 6

Finishing touches included refining the tablecloth and shadows, and turning the pot on the left side more to the left to contrast with the other vessels. Gaydos added Japanese lanterns to the center jug and made corrections in the chair.

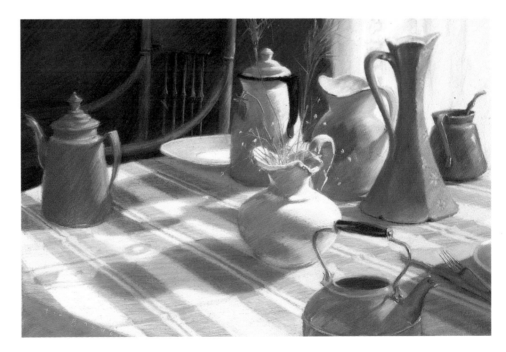

Creating Value Patterns: Two Views

Jill Bush did her first version of the setup on prepared 100 percent rag board (dusky rose), textured with Res-N-Gel and Pyrotrol. Pyrotrol is the brand name for pyrophyllite, a member of a large family of hydrous alumina silicates used to make clay and porcelain products. The Res-N-Gel is rolled on and the Pyrotrol is sifted on while the surface is wet. Then the surface grit is dusted evenly over the surface. She used the photo as a value study and had it made into a laser print. She studied the photo intermittently for a month to consider how she would make changes. She felt the colors sug-

gested themselves — lavender and old lace — a woman's things — traces of her life, showing the warmth (sunlight) she must have brought to her family and the softness and comfort that was hers to give. Making corrections in the divisions and proportions of lights and darks to alleviate overcrowding, and eliminating some objects, Bush worked to develop a soft-edged painting to reflect the overall mood.

Bush worked on her second version with the same preselected assortment of pastels. Her working surface was stretched Fredrix pastel canvas, and she rendered a slightly cooler version.

She zoomed in on one section of the photo and eliminated the dark background and the high chair. She wanted the feeling of a cool morning, before the day's activities, with the warmth of kitchen fires — the breakfast table that greets you when you first get up on a sunny winter's day.

Bush suggested a 1¾" wide silver frame with rosy red mottled finish and a carved lip, and a ¾" wood liner covered with white linen. An alternate framing would be 2" wide gold, mottled finish with carved lip, and a ¾" wood liner covered with a natural linen.

STEP 1

Using vine charcoal, Bush placed her drawing and developed negative shapes. She used the charcoal to establish midtones and darks. She also introduced caput mortuum, which is close to the hue of the board, and a lighter value for clarification of lights on the handles of the collected objects.

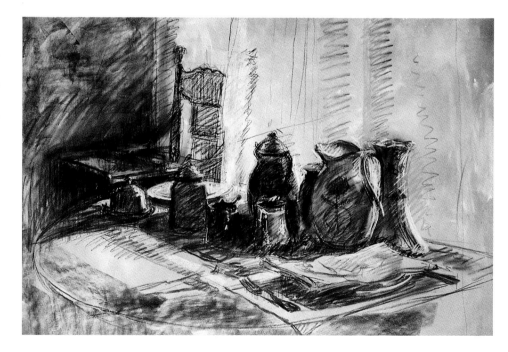

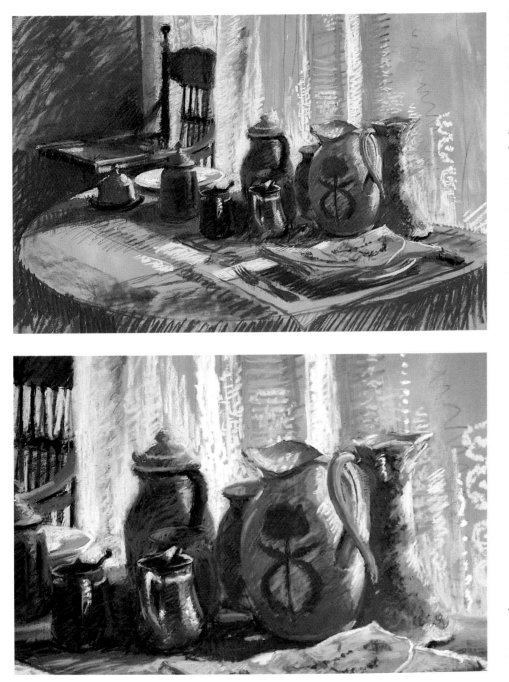

STEP 2

Keeping her palette subdued, she began choosing colors for the chair (sienna and violet), for the tablecloth and vase (whites and off-white), pinks for the roses, and soft greens, golds, reds and blue for the coffeepot. She stroked the pewter items with gray-violets and greenish-yellow umbers, and worked on the handle of the coffeepot with indigo and light gray-violet. The shadow pattern falling across the table acted as a half-tone. At the lower left, she darkened the shadow with dark purple-gray to create a mystery. Light areas were developed with Sennelier pale violet, and medium value purple-brown was used for the table midtones. Rembrandt red-violet was used for the table edge, for the vertical shadow between the curtain and wall, and to illuminate the chair.

STEP 3

Correcting drawing errors, Bush continued developing light-and-shadow patterns on the table and illusion of the folded napkin. Sennelier pastel in pale, clear peach was used for bright reflections, edges of napkins, and the brightest, glowing light filtering through the curtains.

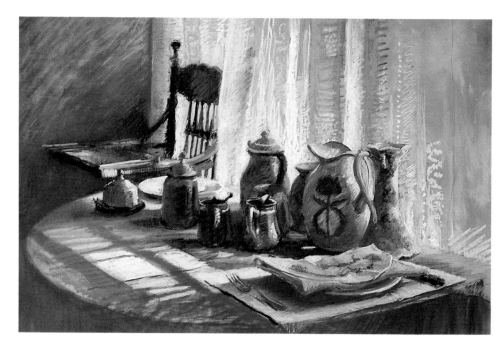

STEP 4

At this point, Bush discovered that all the colors needed intensifying. She put flesh and peach tones into the curtains, used Nupastel blues for the inside of the large pitcher and improved color in all parts of the picture. To remove the somewhat monochromatic look, she worked pinks, red-violets and blue-violets into the shadows. The picture took on a late-afternoon quality.

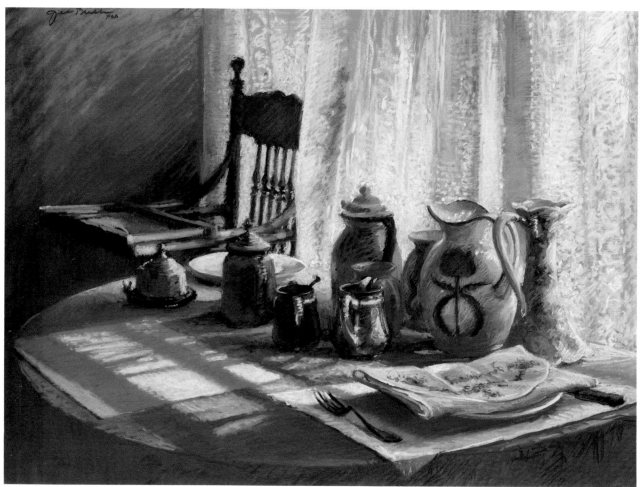

Timeless Room, Precious Objects
Jill Bush
20½″ × 30″
pastel

STEP 5

Even though the palette for this painting included 115 pastels, Bush felt she had maintained a strong value pattern throughout the evolution of this painting. For the final step, she made last-minute adjustments of drawing, color, light-and-shadow patterns, and lost and found edges. At last, she used large mat corners to look at the finished pastel.

Basic Still Life Techniques

STEP 1

Working from the preliminary altered photocopy, Bush blocked in the masses with a violet Le Franc pastel of medium hardness. She blocked in the masses, cutting into them with titanium white pigment and turps substitute (a turpentine substitute that cuts fumes and odor). Then she pushed and pulled shapes to place the composition.

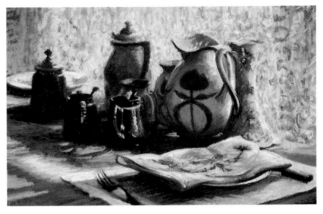

STEP 2

Bush worked in cool analogous color combinations of blue-green through red-violet, enlivened by small touches of their complements or split complements. The colors are purer in hue for the second version, with few grays or umbers.

Timeless Room, Precious Objects II
Jill Bush
12" × 18"
pastel

STEP 3

Many subtle touches were completed in this layer. Highlights were placed on the creamer and tops of vessels, and vases were reshaped. With slight corrections to the drawing and color, Bush brought the painting to a close.

DEMONSTRATION
Subdued Color for an Intimate Scene

Using Canson dark brown paper to develop the rustic charm of the scene, Foster Caddell departed from the photograph to reassemble the scene. He rearranged the objects into a more open composition with light drifting across the table. Using a carefully worked drawing placed in a light pastel on dark paper, he developed the major value range and a strong abstract pattern to give the pastel beauty and authenticity. Caddell says he has never made a true abstract painting but believes in the importance of abstract design. He sees art as a means of communicating to the public, and his work always has interesting subject matter.

STEP 1

In keeping with the rustic charm of the subject, Caddell chose to work on Canson paper with Sennelier pastels (above). Sketching with great freedom, he aimed for good design and placement of objects, rather than specific delineation.

STEP 2

After designing the subject, he established the main value range (above right). He was intrigued by the large area of light coming in the window through the curtains. He covered the paper with a layer of pastel to tone down the dark brown color and introduced warm tones across the table and cool areas in the crockery on the right.

STEP 3

Here (right), Caddell carried the image further and developed the variations of color. He imagined some foliage outside the window to give green to the light mass. He kept the ellipse at the top of the vase at right angles to the axis of the object. The whole butter dish on the left is drawn, even though some of it will be cropped.

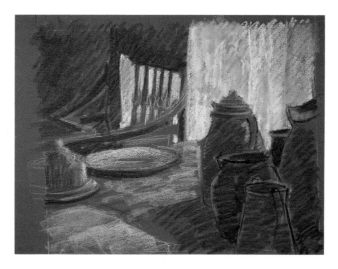

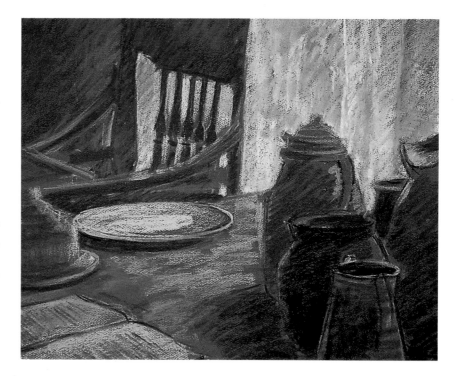

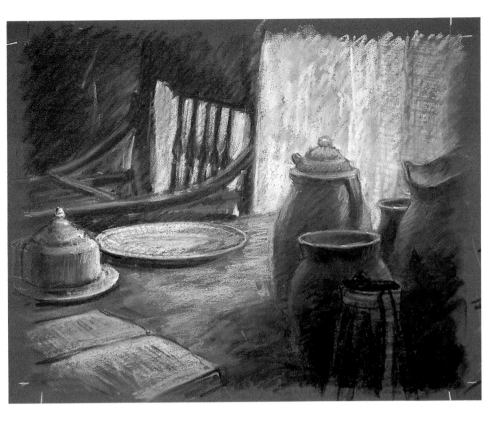

STEP 4

Aiming for a greater sense of form and subdued values, Caddell used the full range, placing black on the right foreground. All objects were developed with a sense of where the light is coming from. This is one of the most important elements in depicting reality. The book on the left thrusts diagonally to direct the viewer's eye back into the picture.

STEP 5

In this final stage, Caddell brought everything to the conclusion that he felt the subject deserved. Colors in the crockery were deepened and highlights around the rim of the foreground pitcher were made to reflect the window light, which gave even this one small section a full range of tonal values.

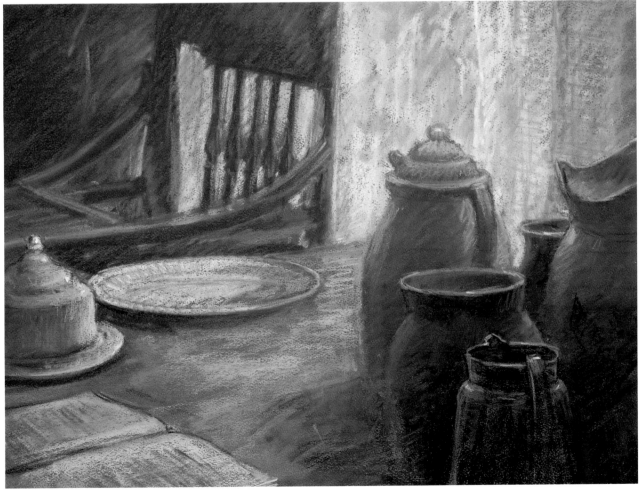

Layering With Fixative for a Glowing Surface

Anita Wolff's interpretation of the photo was impressionistic. Her goal was to show the luminosity of color. Preparing a master drawing on white drawing paper, she traced it and transferred the traced drawing to black Canson paper. She then works out a dy-namic and moving composition, giving careful attention to patterns, a complementary color scheme, strong tonal values, and a good directional light source. She created a tactile and glowing finish by using multiple layers, each sprayed with fixative. Her recommen-dations for framing were to use a gold molding, semi-ornate and wide. To complement the blue in the painting, a wide silver molding would also be effective.

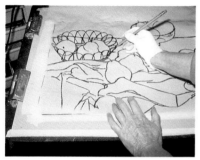

STEP 1

Wolff made a complete drawing of the subject, checking relationships of the still-life objects: napkins, fruit, basket and tablecloth. She then made a tracing of the drawing.

STEP 2

The traced drawing was coated with orange pastel and taped chalk-side-down to the black Canson paper. The drawing was transferred by pressing down on the lines with a pencil.

STEP 3

With attention to lighting, Wolff laid pastels in flat to tone the picture, starting with the basket in a purple-brown, the pears with two shades of violet, a burnt sienna red for the napkin, and turquoise for the tablecloth.

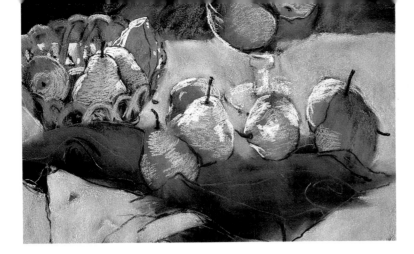

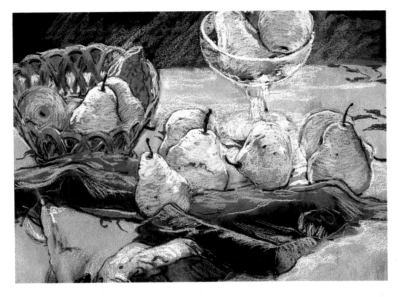

STEP 4

The artist then used a paper towel to wipe off excess pastel and rub it into the texture of the Canson paper. She outlined the fruit basket and some other items with black pastel.

STEP 5

Wolff worked over the underpainting of violet. The colors took on a glowing quality because of the complementary influence. She kept her pastel strokes apart and continued working on the pears, basket and some of the pears on the table. She used a blue-gray on the glass compote and the tablecloth.

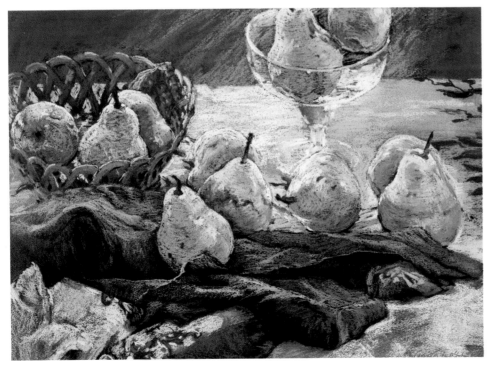

A Symphony of Pears
Anita Wolff
14¾" × 19¾"
pastel

STEP 6

Final details were laid in, and she made careful choices about emphasis and color change. The compote was refined with Thalo blue. She worked to make each piece of fruit glow. There are more than fifteen separate color notes in the pears, which enhance the richness of the painting.

INDEX

Apples on Table, 101
Autumn Still Life, 35

Backgrounds, painting, 18-19, 32, 47, 59-60
Bittersweet and Apples, 72
Black Antique Clock, 37
Blue Ginger Jar, 12
Board, texturizing, 110
Brush Can, 5
Brushes
 bristle, 10
 cleaning, 4-5, 7
 dauber, 4
 oil, 4, 73
 storage and transportation, 7
 washer, 4
 watercolor, 2, 6-7
Bush, Jill, 107, 110-113

Caddell, Foster, 107, 114-115
Canvas, toning, 5, 84
Carnations in Winter, 48
Chocolate Brunch, 48
Chrysanthemums in Oriental Vase, detail, 69
Color,
 building, with lines, demonstration, 64-65
 creating rich, with limited palette, demonstration, 56-60
 families, 52, 54
 high-key, 17
 intensity, 38, 53-54, 112
 local, 90
 mixing, 54-55
 planning, 82
 primary, 52
 principles, 52-65
 properties, 38
 vibration, 64
Color wheel, 55
Colorful Fruit and Flowers, 18
Composition
 and design, 16-17
 balance in, 14-16
 improving, 15
 planning, 14, 18
Contrast
 in tonal value, 38-39
 textural, 62

Deichler, Deborah, 49-51
Dimension, creating illusion of, 17, 28, 32, 39

Drawing
 board, 10
 preliminary, 36
 project, 24-25

Easel, 10
Edges
 blending, in oil, 76
 lost and found, 74
 soft, 22, 35, 67, 101
Effects, special, controlled drip, 73

Falk, Joni, 56-57, 61-63
Family Setup, 92
Fixative, using, with pastel, 11, 98, 100, 116
Focal point, 39, 81, 83, 85, 94, 98, 100, 108
Form
 building, 23
 capturing three-dimensional, demonstration, 50-51
 defining, 28-29, 32, 35
 unifying, exercise, 30-31
 See also Modeling; Shapes, massing in
Framing, 108, 110, 116
Fruit With Luster, 81

Gaydos, Tim, 107-109
Gesture, capturing, 26
Gesture-value sketch, demonstration, 41
Gouache, 49
Grapes and Apples, 72
Gray, using, 18

Happy Wanderer, 19
Highlights, adding, 59-60
Hopi Treasures, 62
Hue, 38, 52, 54
Humidor With Easter Basket, 51

Iris and Hat, 83

James, Bill, 64-65
Jubb, Kendahl Jan, 94-95
July Arrangement With Peaches, 95

Kitchen Interior With Flowers, 3
Knife, painting, 4
 See also Techniques, oil, knife work
Kunz, Jan, 21, 66

Lavender and Blue, 61
Light
 color of, 54
 direct, 70
 indirect, 26
Lighting

back-, 92
 bold, creating, 50
 reflected, 70, 91
 sources, 22
 studio, 2
Lines
 creating fine, 7
 See also Color, building, with lines, demonstration
Lund, Jane, 102-105

Mahony, Pat, 49
Materials, basic, 2-11
Medium
 painting, 5, 22
 See also Oil painting; Pastel; Watercolor painting
Melon and Grapes, 100
Modeling, 23, 32, 34, 44, 51, 60
 See also Form; Shapes
Mood, creating, 48
Moran, Patricia, 69-71, 78

Nice, 49

Objects
 collecting, to paint, 12-13
 flat, painting, 28
 grouping, 30
 relating, in a setup, 83
 round, painting, 28
Oil painting, 3, 5, 12, 16-19, 31, 35, 37, 61-63, 78, 81, 83, 85, 87
 considering color, demonstration, 82
 materials, 4-5, 22
 palettes, 4-5
 project, 22-23
 setting in the yard, demonstration, 86-87
 surfaces, 4
 tying values and colors together, demonstration, 80-81
 using neutral tone, 78-79
 See also Brushes, oil
Oils, suggested colors, 4

Paint thinner. *See* Turpentine
Painting
 chiaroscuro, 98
 high-key, 44
 low-key, 44
 miniature, 63
 outdoors, 86-87
Paper
 and board, 8
 colored, 11

etching, 11
texture, 72
See also Board, texturizing; Surfaces
Paper, gray
 charcoal and chalk on, demonstration, 42-43
Pastel, 49-51, 65, 72, 100-101, 105, 107, 109, 112-113, 117
 applying, 11
 color, building, 98
 creating value patterns, demonstration, 110-113
 drawing, materials for, 10-11, 102-104
 enhancing mood, demonstration, 108-109
 painting studio light, demonstration, 98-101
 removing, 11
 rendering fine detail, demonstration, 102-105
 soft, selecting, 10
 storing and transporting, 10
 suggested colors, 10
 surfaces for, 11-12, 72
 types of, 10
 using subdued colors, demonstration, 114-117
Pastel Shades, 78
Perspective, drawing, 36
Petals and Clay, 63
Photos, working from, 106-117
Pike, Joyce, 12-13, 16-19, 36-37, 73-75, 77, 81, 83, 85-87
Pionk, Richard, 72, 98-101
Porcelain Pitcher, The, 16
Pretty Bouquet, 85
Prior, Scott, 44

Razor blade scraper, 5
Red and White, detail, 69
Red Sneakers, 44
Reflection, 72

Sandpaper, 10
 See also Surfaces, sandpaper
Setting in the Yard, 87
Setup
 composition, 20-21, 32
 grouping objects, 30-31
Shadows
 cast, 16, 48-49, 74-75, 89, 92-93
 drawing, exercise, 48
 using, to create mood, 48-49

Shapes
 massing in, 26-27, 32
 negative, 110
Sheean, Mary, 107
Sideboard, 49
Sketches, monochromatic, 56
Sovek, Charles, 2, 5, 31, 35
Space, negative, 16, 18-19, 94-95
Still life
 arrangement, 22
 assembling a stage, 20, 22
Still Life in Blue and Gold, 65
Still Life With Plums, Knife, Glass and Bottle, 31
Stine, Al, 6
Strawberries on the Deck, 44
Strokes
 samples of, 73
 scrubbing, 73-74
Studio, workspace, 2-3
Subject treatment
 flowers, 13, 15-18, 37, 56-58, 63, 71, 76-77, 80, 82-85, 87, 96
 fruit, 18, 80, 87-91, 100-101, 117
 glass, 19, 64-67
 leaves, 73
 reflective objects, 68-70, 96-97
Summer Radiance, 63
Surfaces
 board, 72
 canvas, 3-4, 5, 35, 61-63
 Masonite, 4, 31
 paper, 72, 107
 sandpaper, 72
 See also Paper, and board
Symphony of Pears, A, 117

Tea Time, 107
Techniques
 drawing, rule of thumb, 37
 dry brush, 8
 effect of, on paper, 8
 layering color, 102
 laying in color, 56
 lifting out, 7-8, 56-57, 59
 locking in, 84
 masking, 8
 passage principle, 46
 reflectivity, 68-70, 96-97
 rubbing out, 71
 scrubbing, 7, 57-59
 smearing, 50

transparency, 66-67, 69
underpainting, 57, 72, 88, 96, 117
using black, 95
washes, 8, 36, 56, 82, 84
wet-into-wet, 22
wiping out, 8
Techniques, oil
 knife work, 76-77
 overlay, 76-77
 wash, 23, 27-28
Texture
 paper, 8, 11, 72
 watercolor, 8
 See also Contrast, textural
Timeless Room, Precious Objects, 109, 112
Timeless Room, Precious Objects II, 113
Tone. *See* Values, neutral, laying in
Tulips and Sweet Peas, 17
Turpentine, 5

Value scale, painting, exercise, 45
Value-pattern sketch, demonstration, 40
Values
 adjusting tonal, exercise, 38
 color, 38, 53
 home, 45, 47
 in composition, 16-17
 neutral, laying in, 78-79
 planning, 106
 shadow, 48
 transforming color into, exercise, 42-43
 translating to color, 106
 using, to create center of interest, 46
 using, to define form, 28, 32, 54
 working with, 22-23, 38-51, 58, 69
 See also Contrast, in tonal value
Venetian Glass, 19

Watercolor painting, 44, 48-49, 92, 95
 designing with black, 94-95
 materials, 6-9
 painting cast shadows, demonstration, 92-93
 palettes, 9
 suggested colors, 9
 surfaces, 8
 See also Brushes, watercolor
White Still Life, 105
Whites, creating, 8
Wolff, Anita, 107, 116-117
Wright, William C., 44, 48, 92-93